Remember Your stay in York!
Love, MomMom Christmas 2014

CAPTURE YORK

Presented by InYork.com

Foreword

In your hands, you are holding much more than a book of photography. You are holding everything that is great about the York County community.

Capture York is the end result of a massive local effort. Some of the area's best photographers submitted 3,368 photos; then 1,026 contributors voted 165,126 times. You helped us determine which were the best photographs, which images best represent the York community, and ultimately which sights and scenes make up this book. (In fact, we received so many great photos and the community felt so strongly about them that one book wasn't enough—so we're including a DVD with more than 1,000 other photographs).

The quality of the photographs alone would make for a superb book, but Capture York is also a celebration of everything that makes our corner of the world great. The work of the many photographers who participated is illustrative of the region's charm, its beauty, its history and its future. Many of you will find the things you love about York seen through a new lens. Some of you might even find some new reasons you're glad to call York home. We hope all of you will be reminded of the wealth of beauty and talent that can be found in and around York County, as well as a renewed sense of community from seeing York in new ways big and small.

Ultimately, it is the community that made this book possible, and it is the community that deserves the credit for its success. Those of us at InYork.com and the York Daily Record/Sunday News who have had the privilege of working on this project can't thank the participants enough for the time and effort they devoted in taking photographs, voting for images and sharing their favorite shots with friends and family. We think they have made Capture York as great as the county and its people. We hope you agree.

PHOTO BY AMY STAUB

Table of Contents

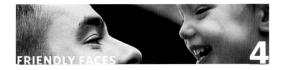
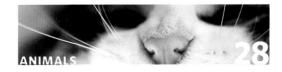
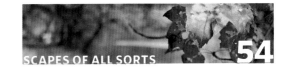
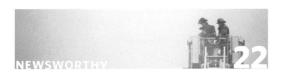

About this book.

Capture York™ is the most unique book project ever conceived. It started with a simple idea: Lots of folks take lots of pictures of the York area — many of which would be worthy of publishing in a fine-art, coffee-table book. Knowing that thousands of photos would be submitted, the question was then posed: How do we pick the best from the rest? The answer was genius. We put the editing power in the hands of the people. Local people. People that know York. People just like you. We asked photographers, doctors, union workers, musicians, moms, right-handed people, pants-wearing folks, or anyone from any walk of life to vote for what they considered to be the photos that best capture the York area. From nearly 4,000 photo submissions for the pages of this book, almost 200,000 votes helped shape what you hold in your hands. It's something that's never been done before: publishing by vote. Enjoy it.

How to use this book.

Open. Look at the best pictures you've ever seen. Repeat. Actually, maybe there's a little more to it. First, be sure to check out the prize winners in the back of the book (also marked with ★ throughout). You'll also want to watch the DVD. It's got more than a thousand photos on it! Here's the caption style so you can be sure to understand what's going on in each photo:

PHOTO TITLE *(location on page, if needed):* Caption, mostly verbatim as submitted. 📷 PHOTOGRAPHER

Copyright info.

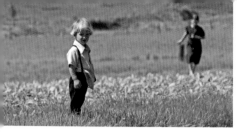
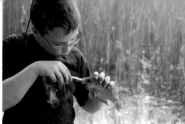
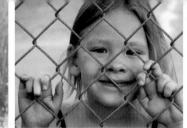
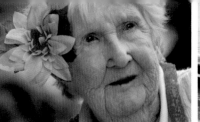
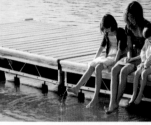

Friendly Faces

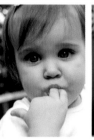
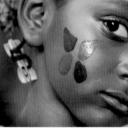

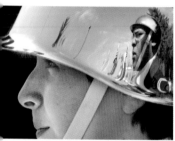
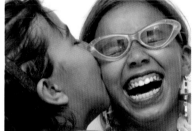
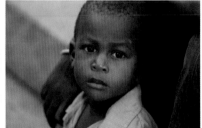
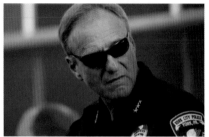
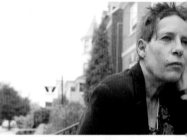

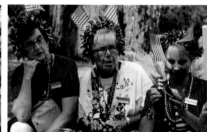
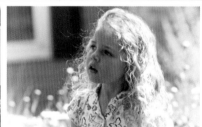
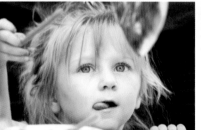

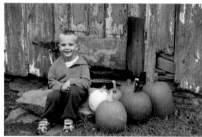

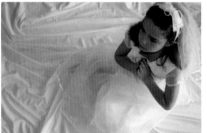
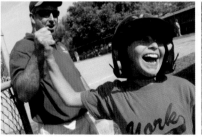
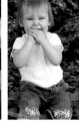

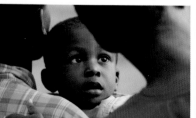
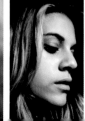
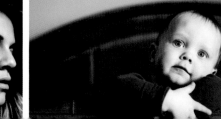
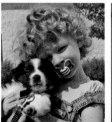

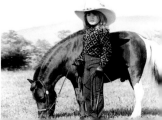

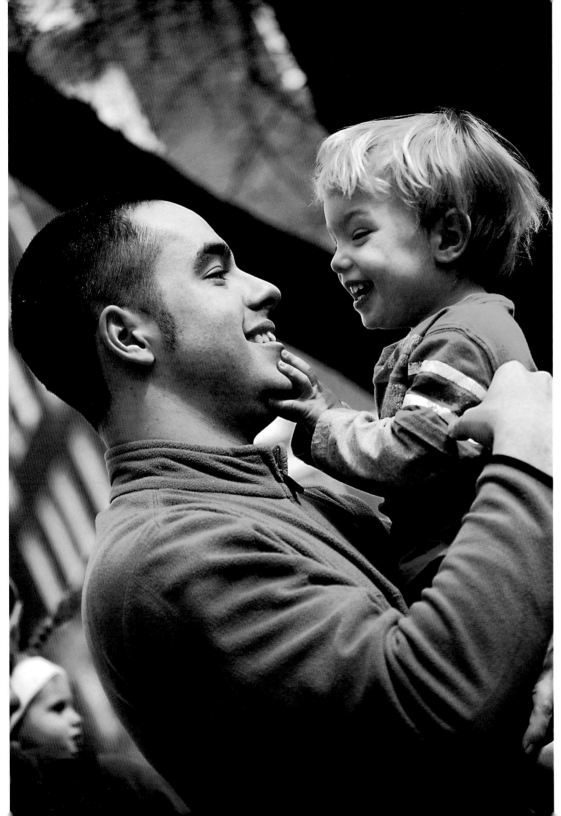

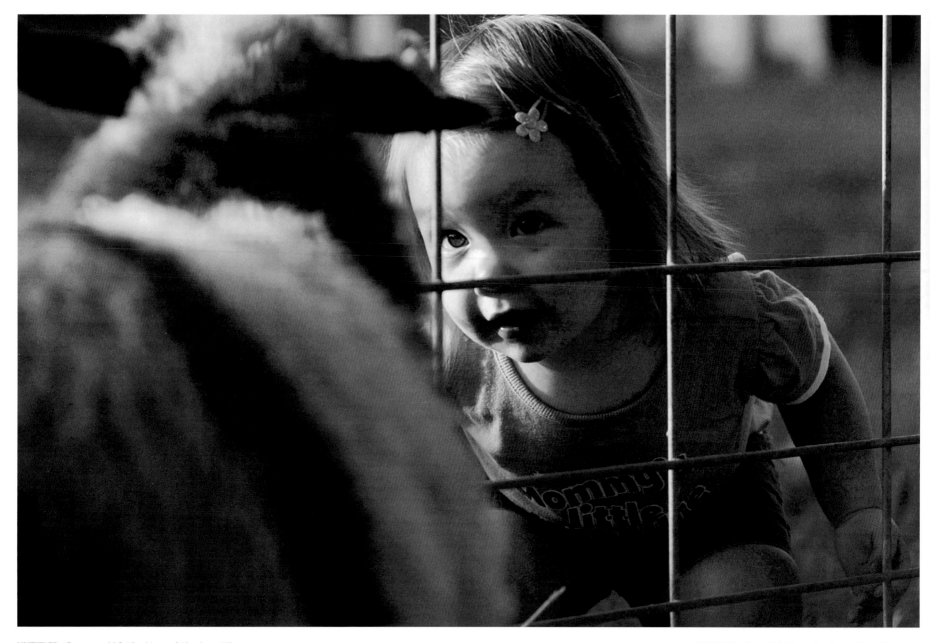

UNTITLED: One-year-old Caitlyn Myers of Aberdeen, MD, inspects a sheep after imitating the noise it made at the Mason-Dixon Fair. 📷 KATE PENN/INYORK.COM

UNTITLED: *(opposite)* Myron Noodleman, the self-proclaimed 'Clown Prince of Baseball,' works the crowd at Sovereign Bank Stadium during a Revolution game. Fans were encouraged to attend the game dressed up as nerds. 📷 KRISTIN MURPHY/INYORK.COM

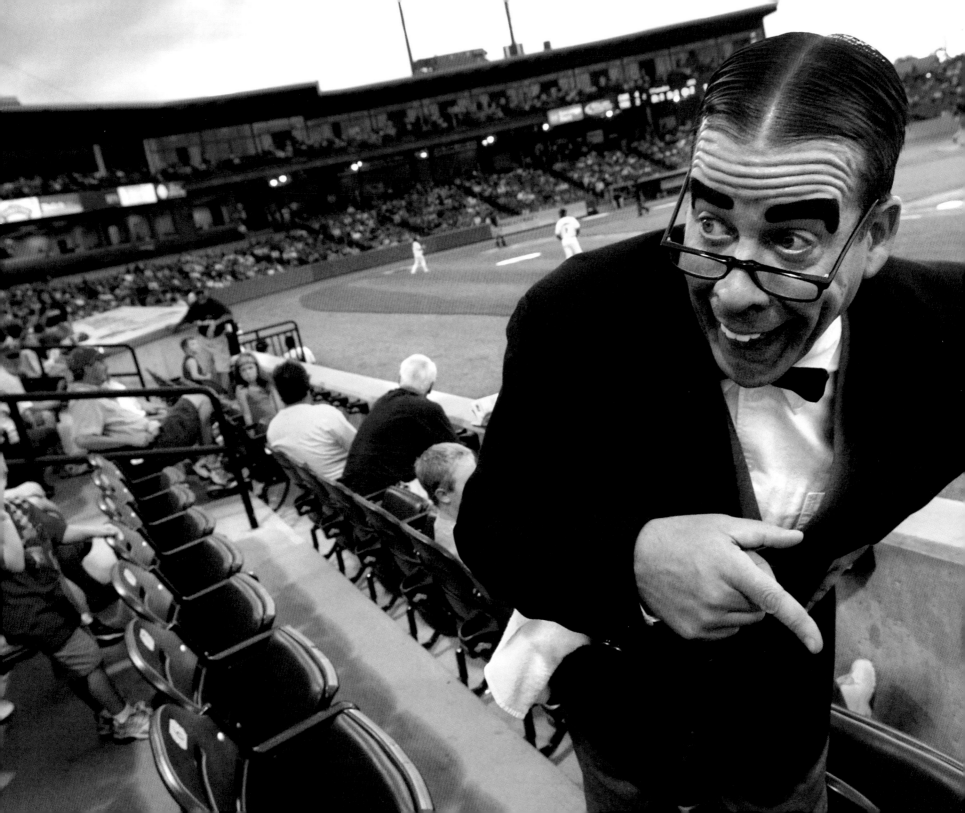

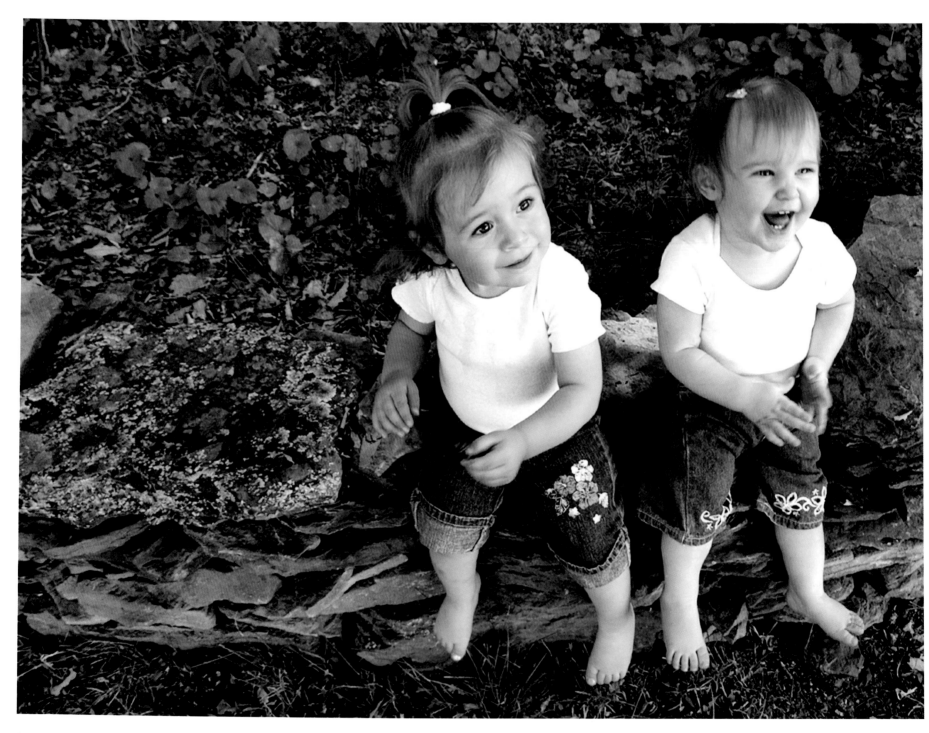

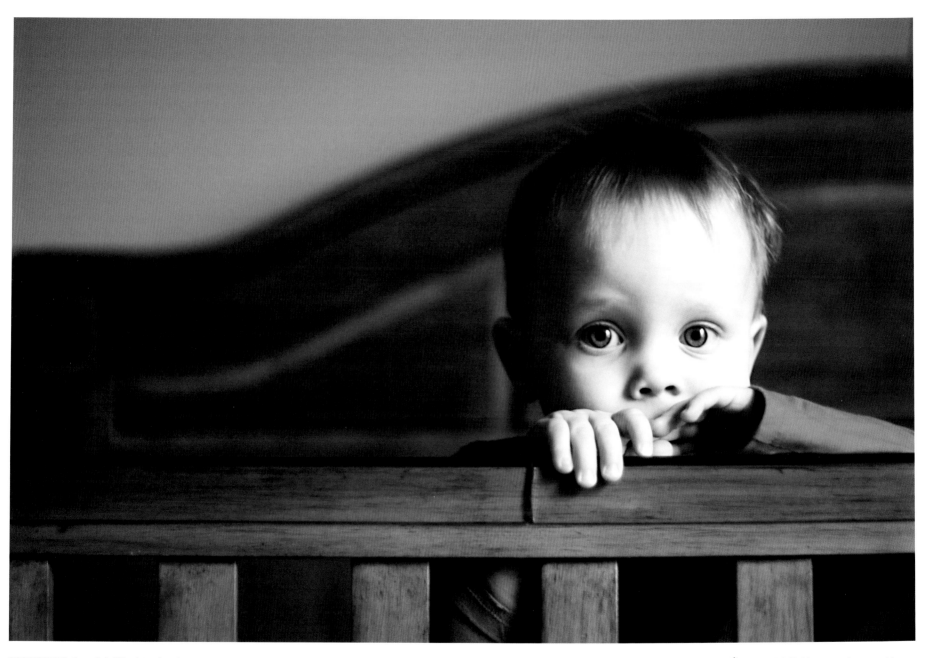

HANGIN' OUT: *(opposite)* Little sisters hanging out at Rocky Ridge. 📷 SARA ZIMMERMAN

★ **PEEK-A-BOO!:** I hope you always want to play peek-a-boo with your Mommy. Photo taken: Etters, PA. 📷 TRACY KAYE

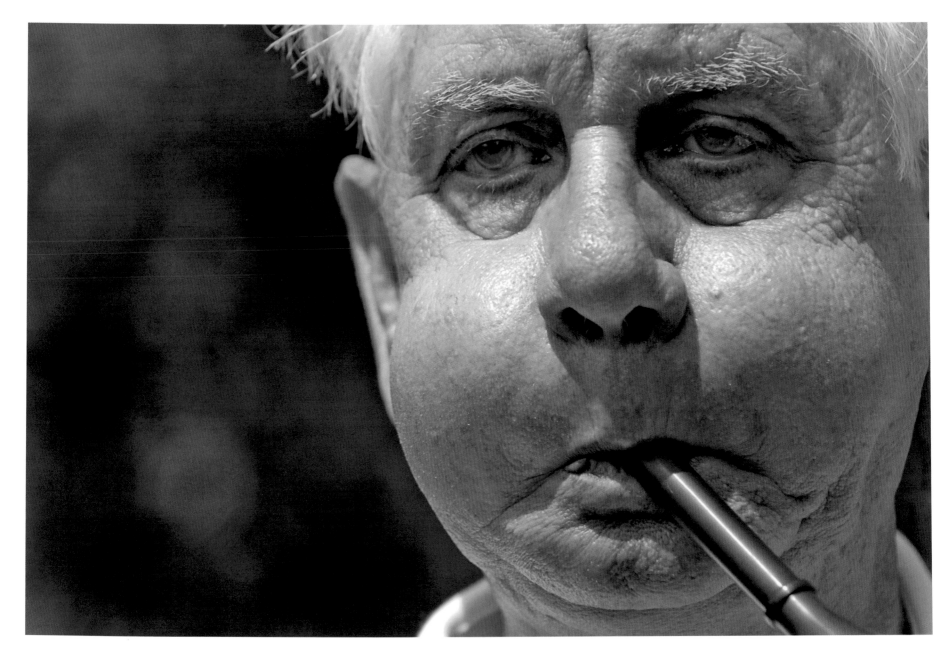

UNTITLED: Scott Erskine of the Zembo Highlanders from Harrisburg plays the bagpipes during a barbecue fund-raiser in honor of Connie Spangler Heindel of Jacobus, who died in a motorcycle crash four years ago.
📷 JASON PLOTKIN/INYORK.COM

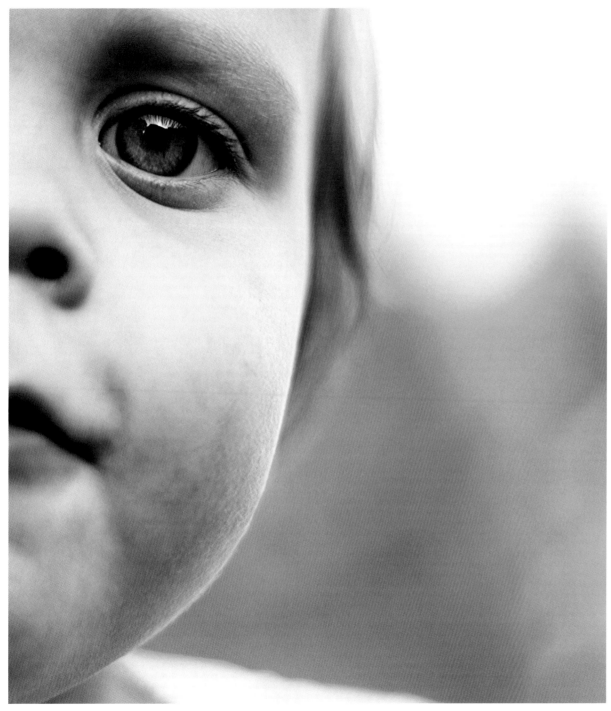

UP CLOSE AND PERSONAL: Up close and personal
with Brady Kaye! Photo taken: Etters, PA. 📷 TRACY KAYE

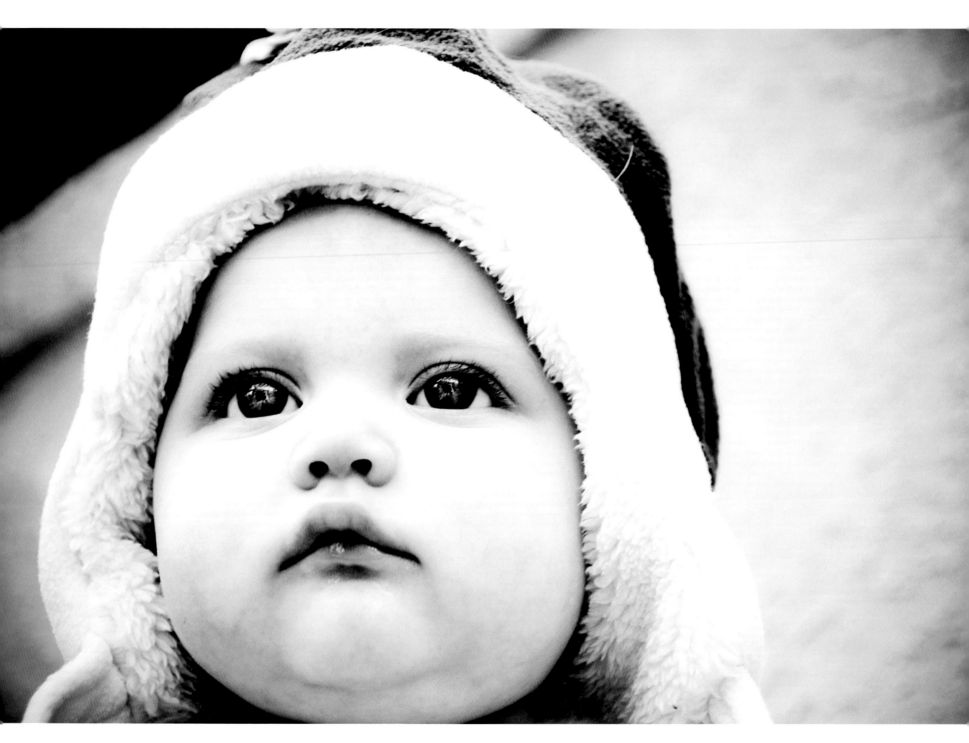

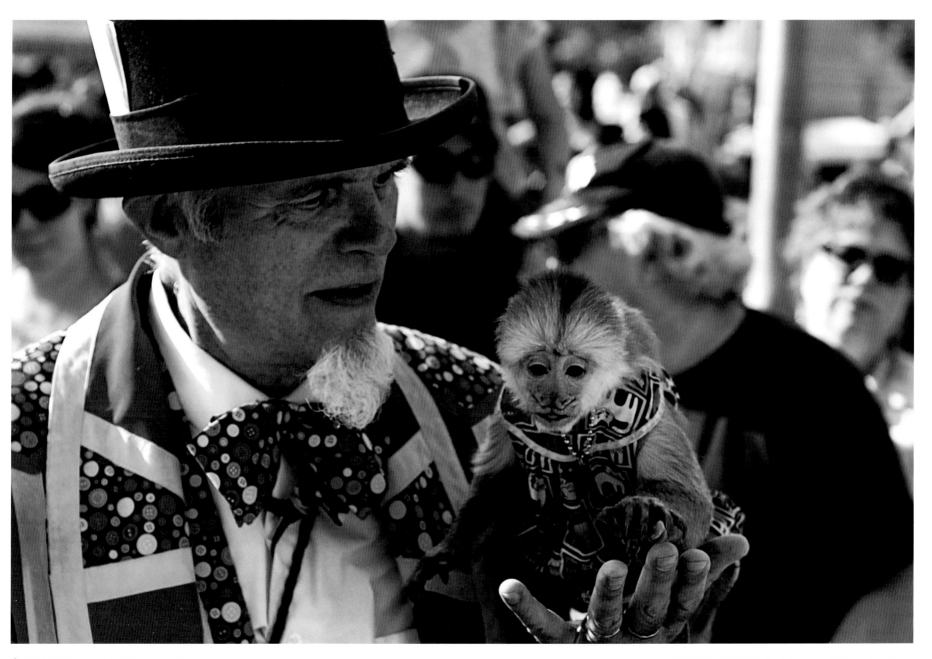

★ **INNOCENCE:** *(opposite)* Will I remember?
Photo taken: Manchester, PA. 📷 TRINITY WALKER

MAN & HIS MONKEY: Here's the man with the monkey who
shows up at the street fair every year. Photo taken: Olde Yorke
Street Fair (Market St). 📷 JASON FEGELY

Schools & Institutions

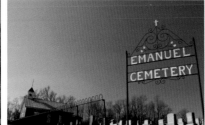

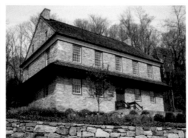

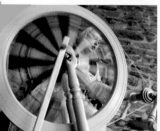
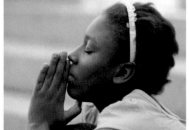
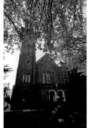
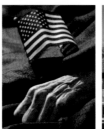
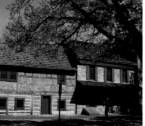
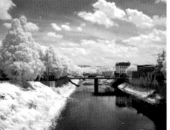

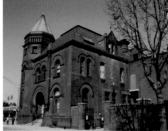
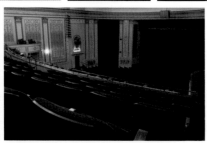
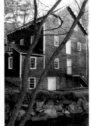
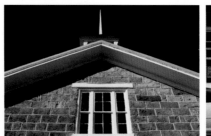

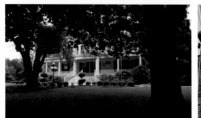

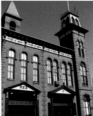

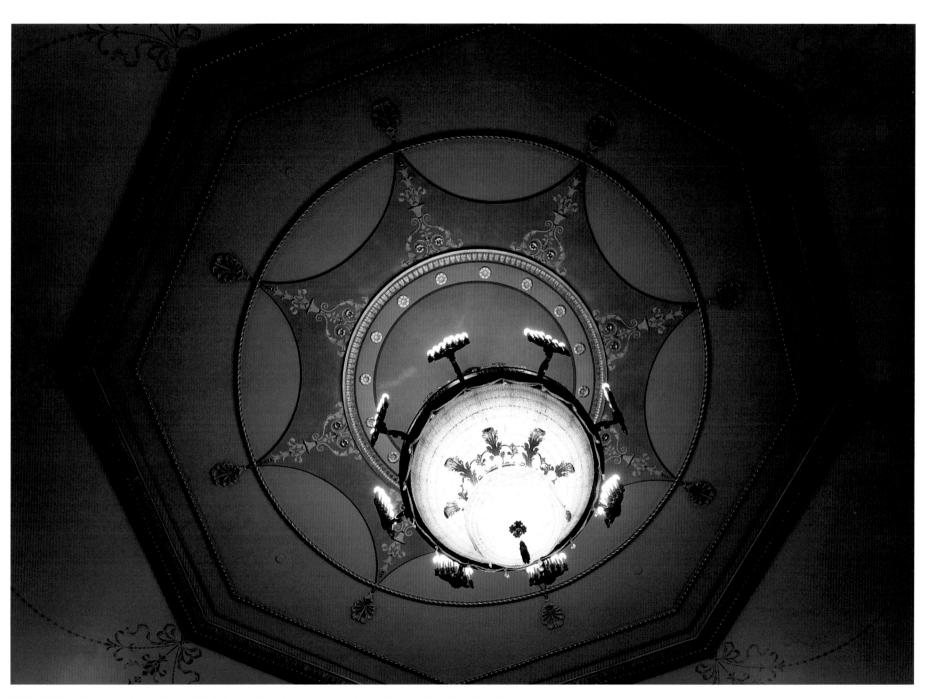

CHANDELIER: Inside the Strand Capitol theatre. This is the main chandelier once you enter the actual theatre. Photo taken: York, PA. ☞ FRANK BELL

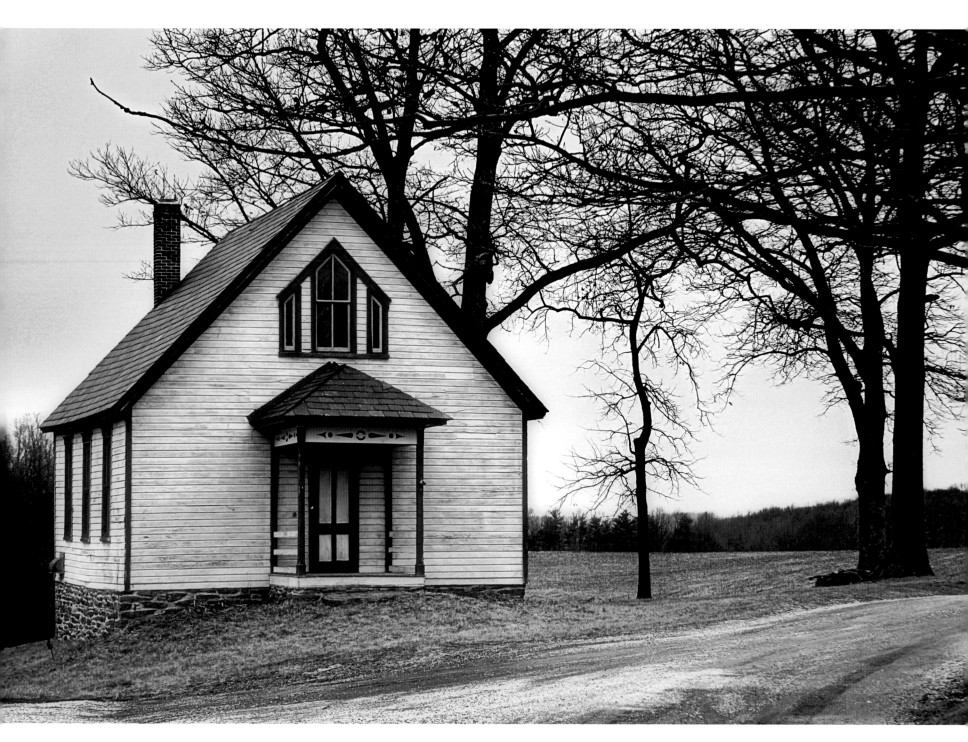

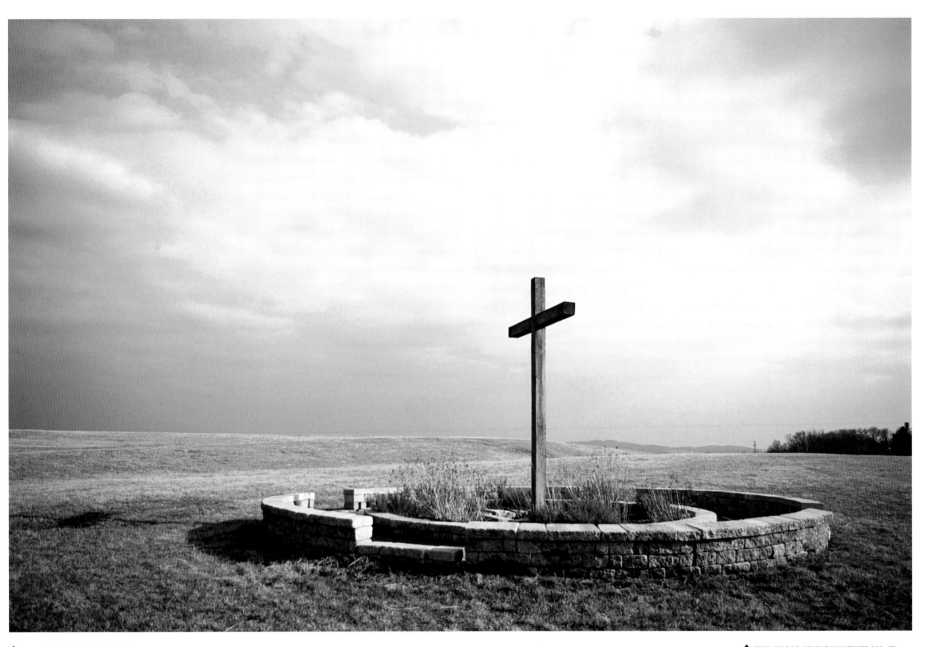

★ **OLD TROUT SCHOOL HOUSE**
(opposite): Old one-room school house located in Southern York County.
📷 JEFFREY A. MOORE

★ **THE CROSS AT ZION LUTHERAN:** The cross at Zion Lutheran against a bright blue sky. Photo taken: Zion Lutheran Church, Brandywine Lane, York, PA. 📷 SETH NENSTIEL

ON TOP OF THE COURT HOUSE: The domes on top of the Court House. I captured this in the morning at 7:35 a.m. Notice the time on the clock. Photo taken: Downtown York. 📷 TONY SCHLIES

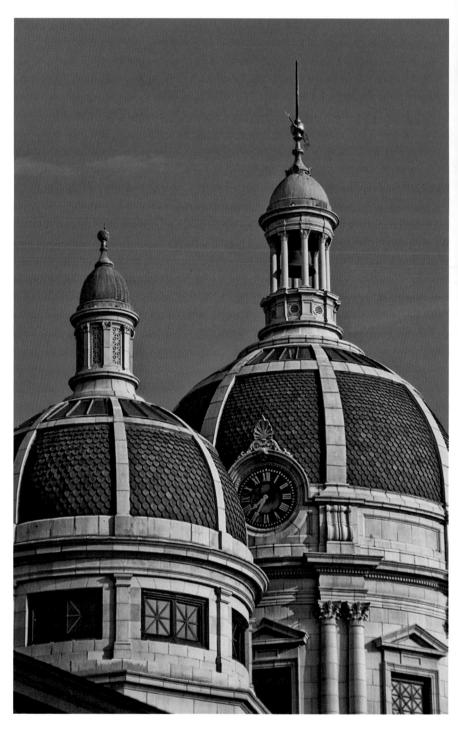

★ **TONGUES** *(top):* I was given unfettered access to The Strand Capitol Theatre here in York. I took hundreds of pictures but unfortunately my cheap tripod ruined a lot of them and caused them to be blurry (I forgot my remote, so each time I took my finger off the shutter the tripod would move), so I've rescued what I could from as many as I could. This is a view from the balcony. Photo taken: Strand Capitol Theatre, York, PA. 📷 FRANK BELL

TOUCH THE SKY *(bottom):* Taken inside the Strand Capitol Theatre. Photo taken: York, PA. 📷 FRANK BELL

PILGRIM: York Fairgrounds. All of the horses (I believe that's what these are called) they use are piled up in one place. Photo taken: York Fairgrounds, York, PA. 📷 FRANK BELL

SINCE I LEFT YOU (*opposite*): York Fairgrounds on a sunny, winter's day. Photo taken: York, PA. 📷 FRANK BELL

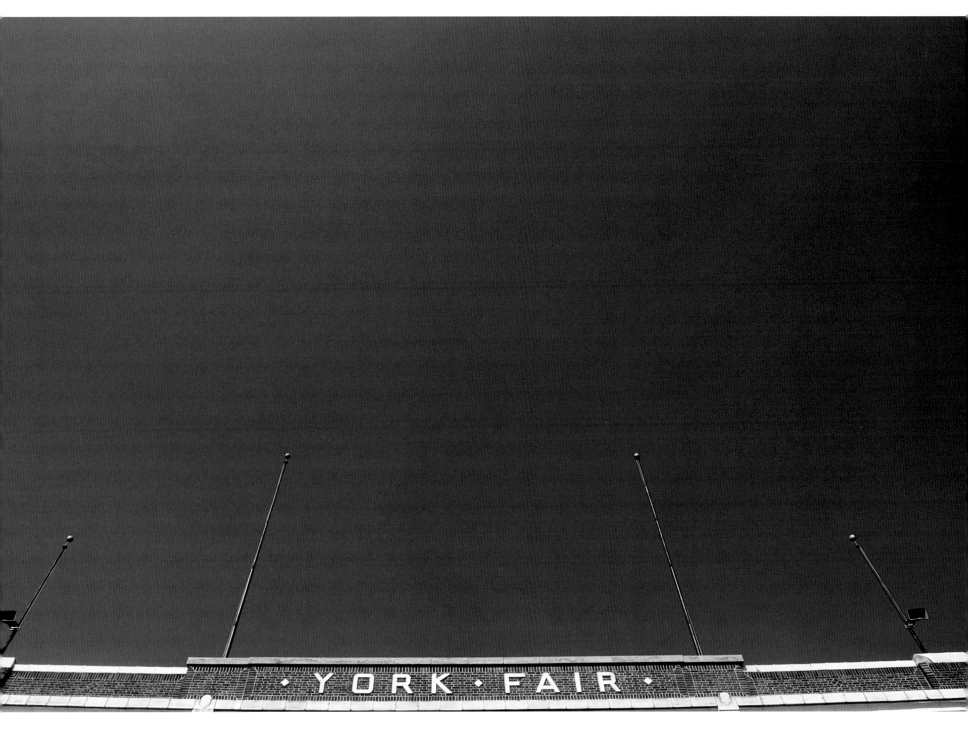

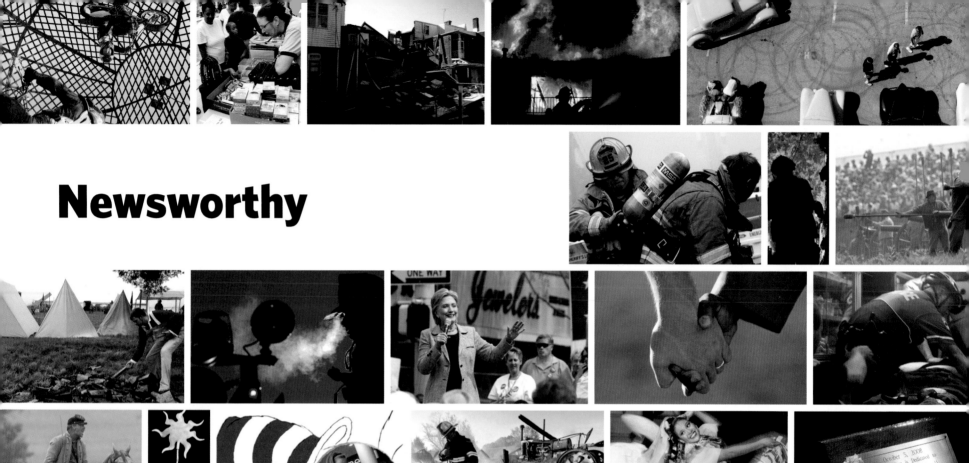

Newsworthy

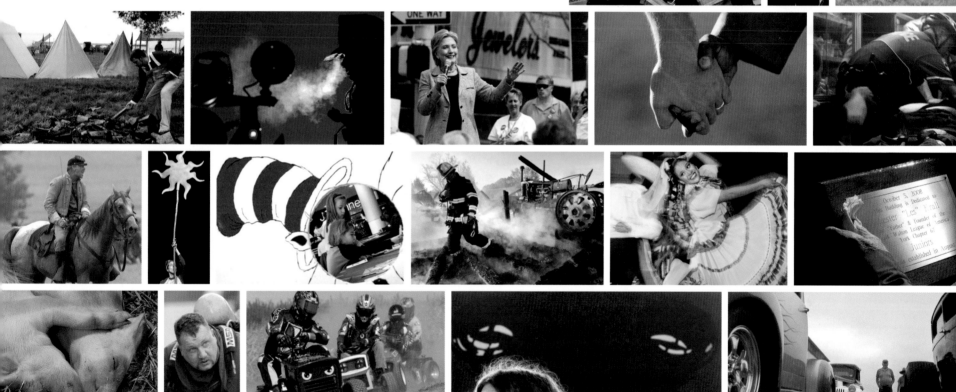

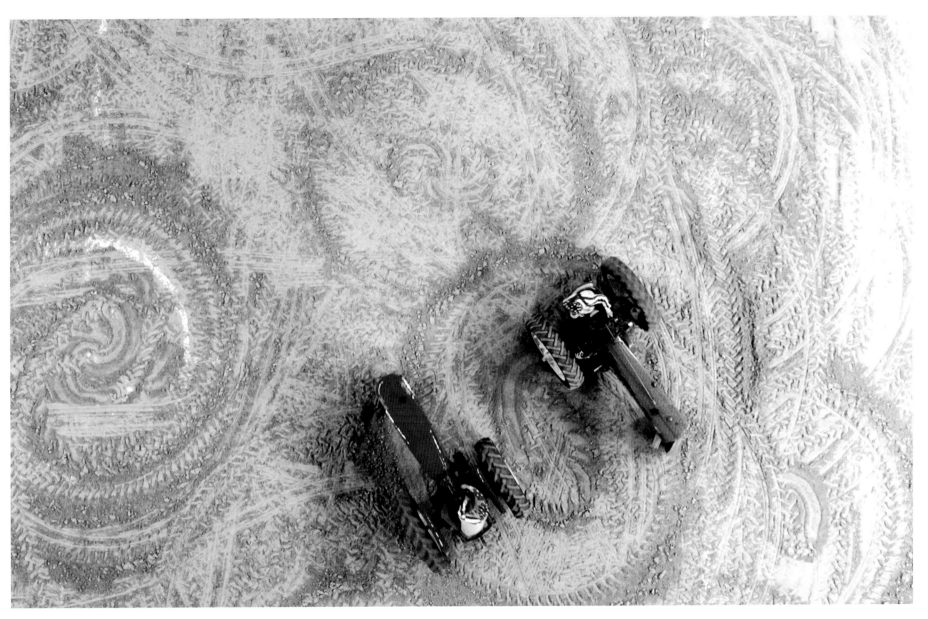

TRACTOR SQUARE DANCING: Members of the Roof Garden Tractor Buddies out of Somerset, Pa., perform in the tractor square dance at the farm show.
📷 JASON PLOTKIN/INYORK.COM

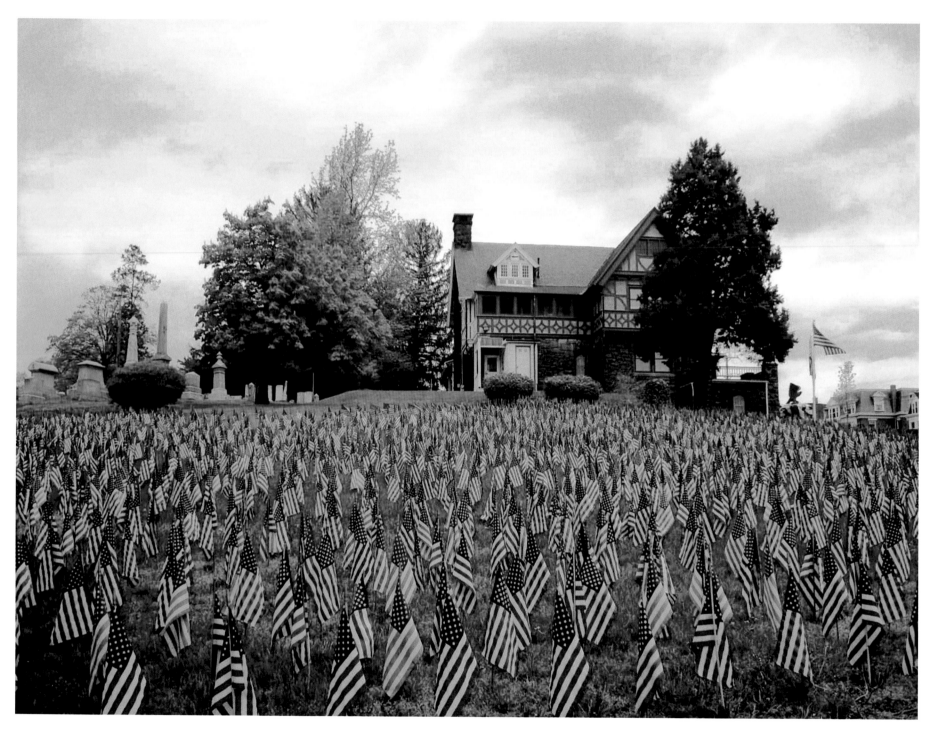

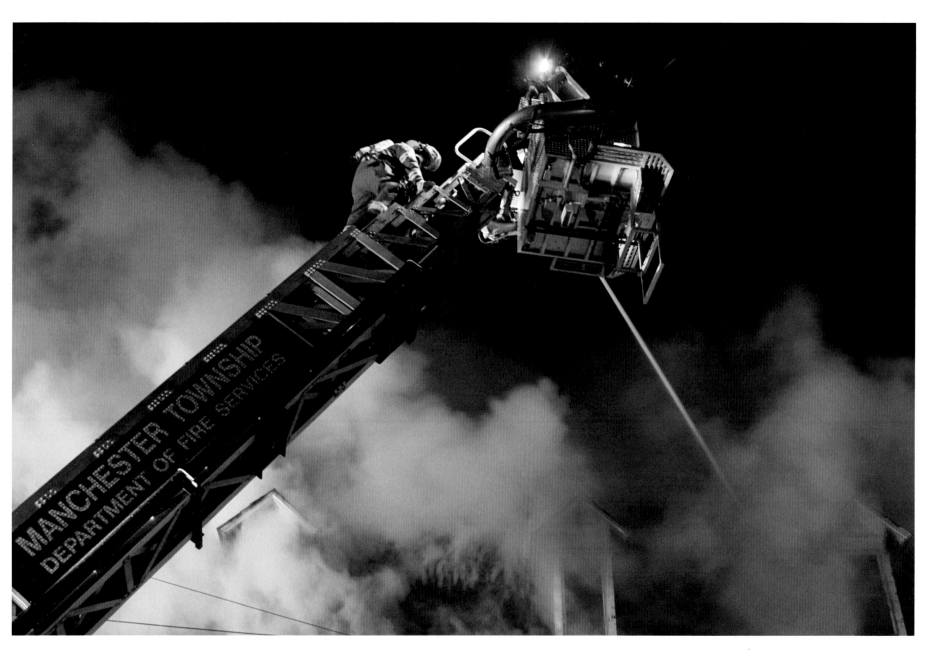

TRIBUTE TO OUR FALLEN HEROES
(opposite): More than 5,000 flags decorate
the entrance to Prospect Hill Cemetery
honoring some of our deceased veterans who
served in Iraq and Afghanistan. Photo taken:
Prospect Hill Cemetery. 📷 DIANNE BOWDERS

⭐ **SMOKY TOWER:** Manchester Township
Fire Company helps battle a multiple alarm
fire in the city. Photo taken: York City.
📷 JEFF HIXON

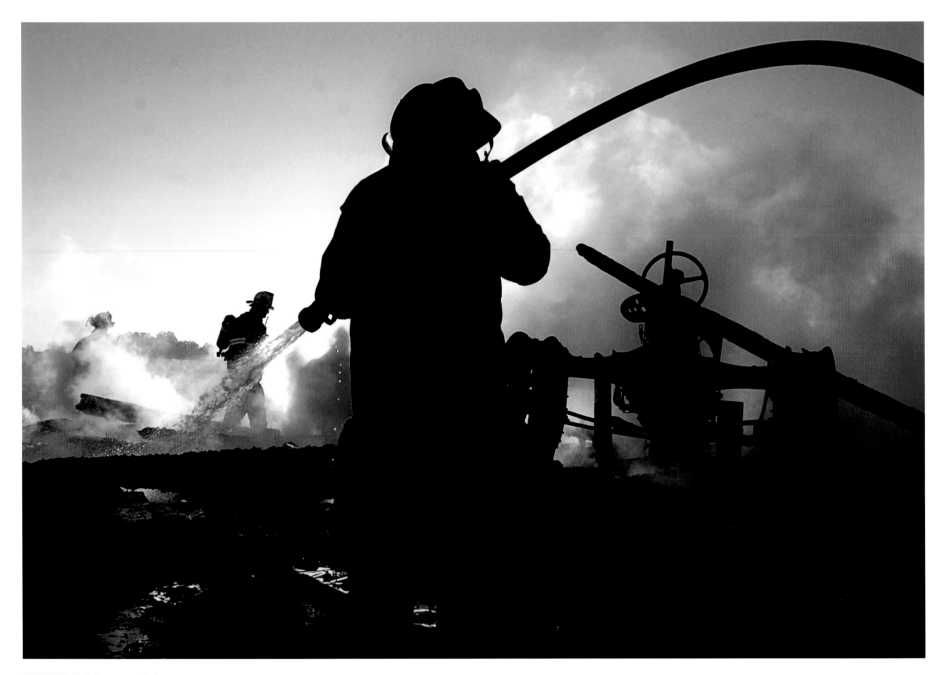

BARN FIRE: Firefighters were called to
an early morning barn fire in Chanceford
Township. 📷 JASON PLOTKIN/INYORK.COM

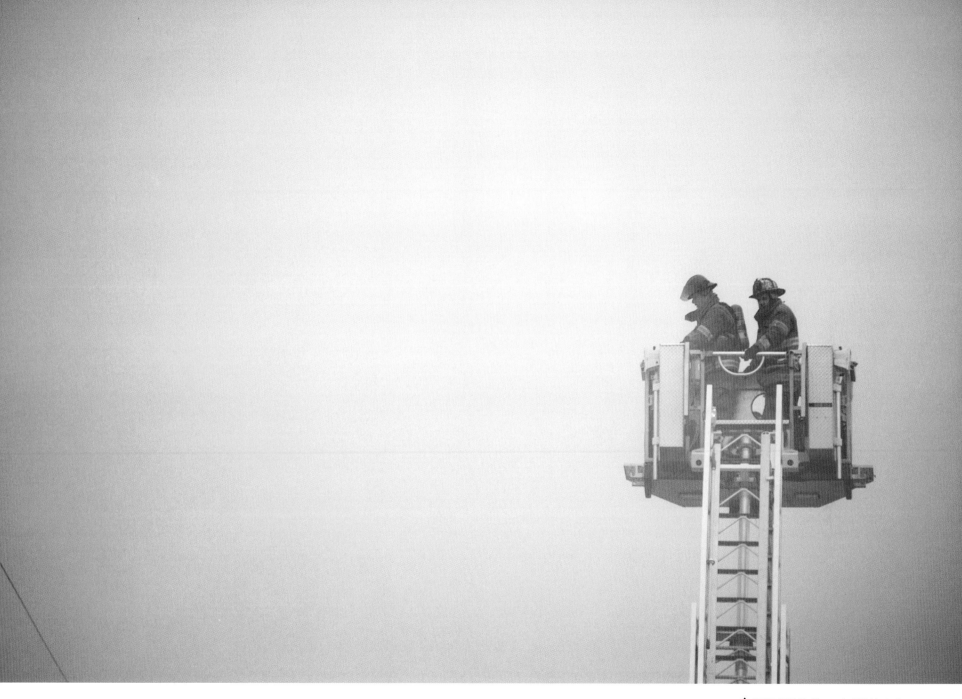

★ **FIRE LADDER:** Fire on the 300 block of
East King Street on November 24th, 2008
Photo taken: 300 block of East King St.
📷 JASON FEGELY

Animals

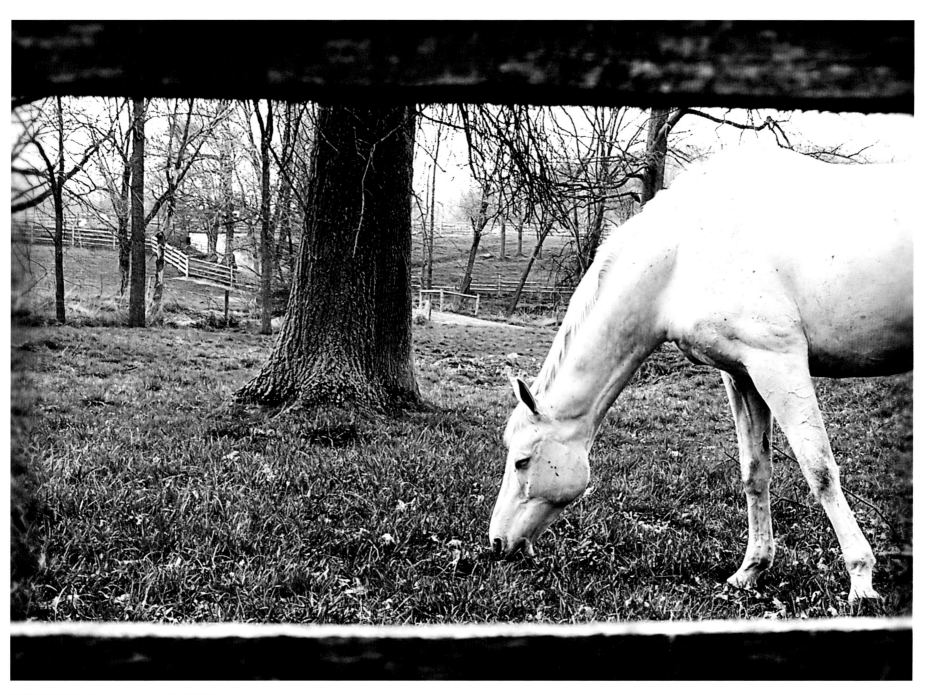

FRIENDLY HORSE: A horse grazes in southern York. Photo taken: near Nixon Park. 📷 JASON FEGELY

★ **FERAL CAT:** A feral country cat living on a dairy farm in Glen Rock. 📷 JEFFREY A. MOORE

★ **SAY AWWWW!** *(opposite):* Bailey caught yawning! 📷 JANICE ZIMMER

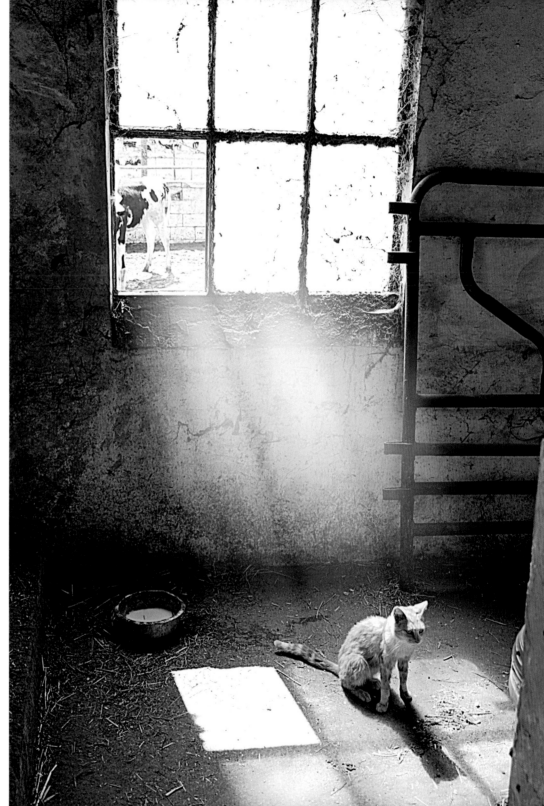

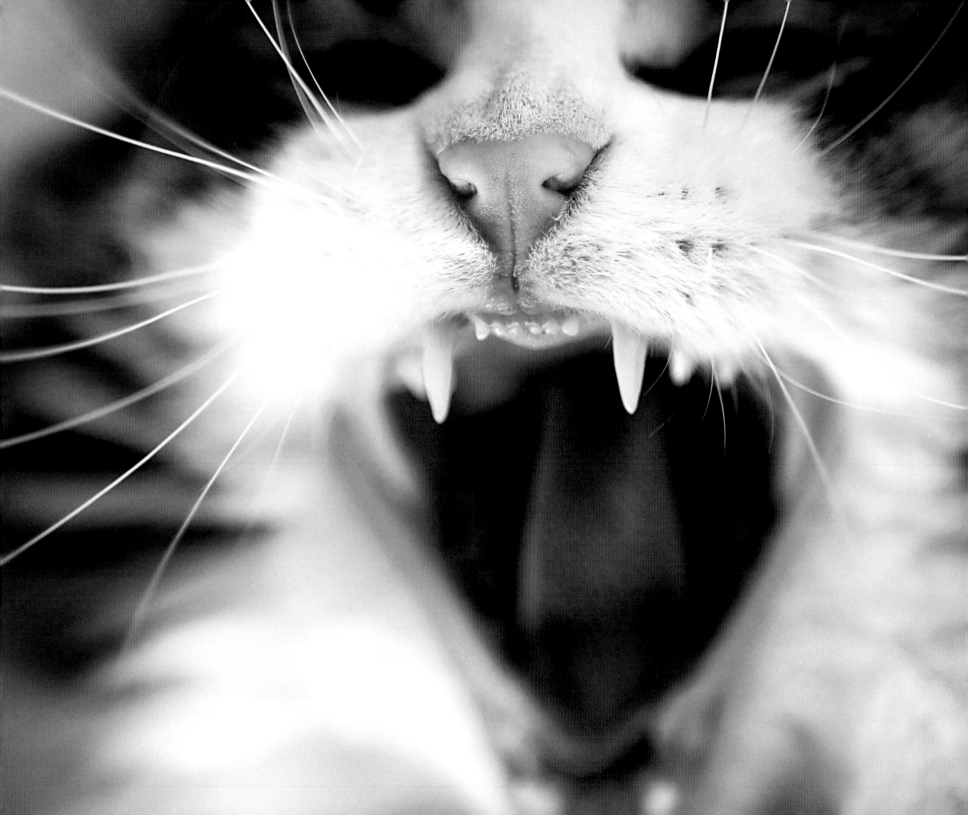

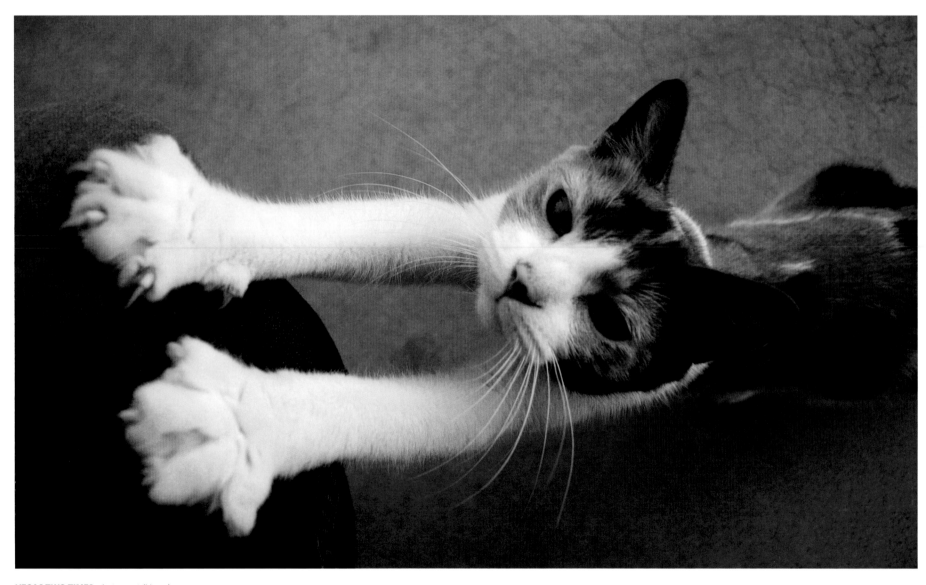

VEGAS TWO TIMES: A stray cat (Vegas) that we took in over Christmas a few years ago. Photo taken: York, PA. 📷 FRANK BELL

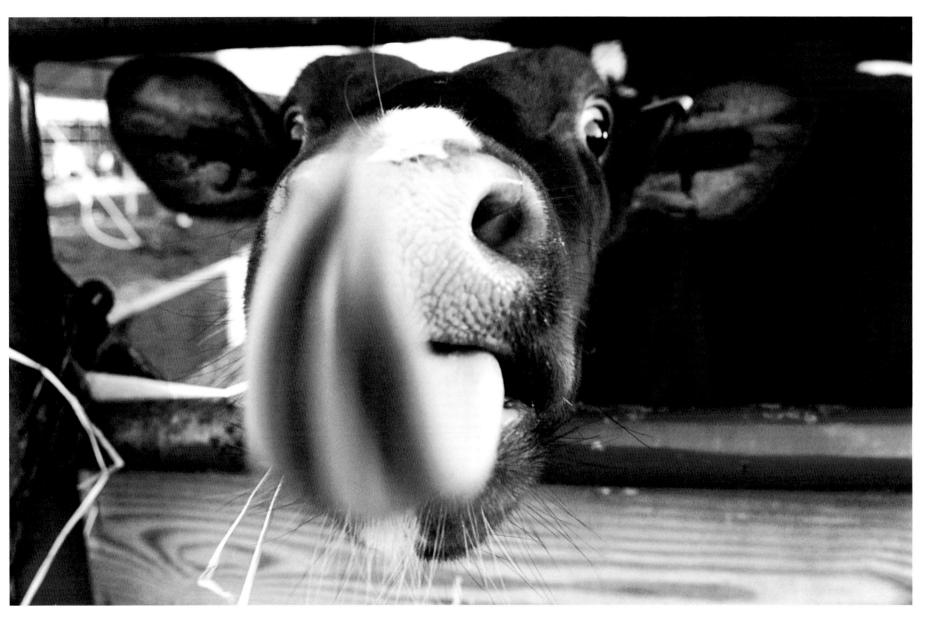

COW TONGUE: A younger cow tries to taste anything that gets within its reach during the Mason-Dixon Fair in Peach Bottom Township.
📷 KATE PENN/INYORK.COM

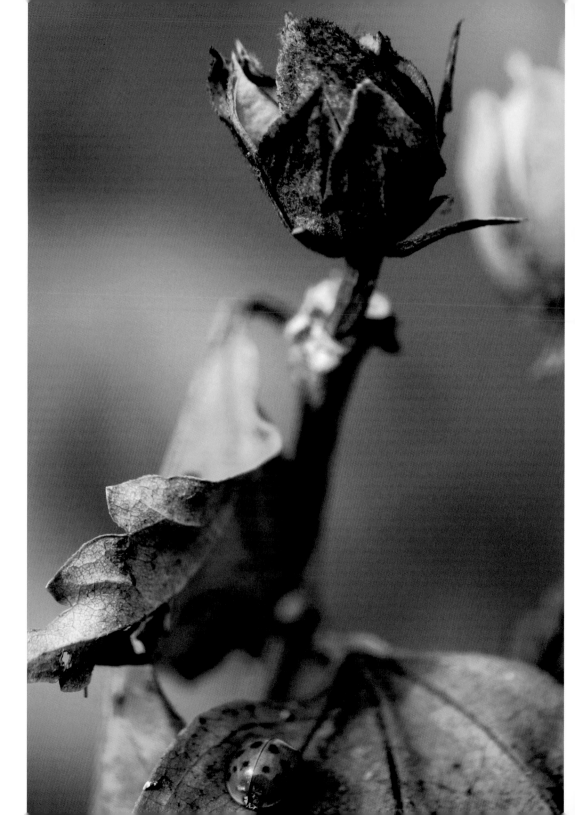

ON THE LEAF: A ladybug on a leaf. Photo taken: York, PA. 📷 FRANK BELL

SUNBATHING *(opposite):* A frog checks out passing joggers at Rocky Ridge. 📷 JASON FEGELY

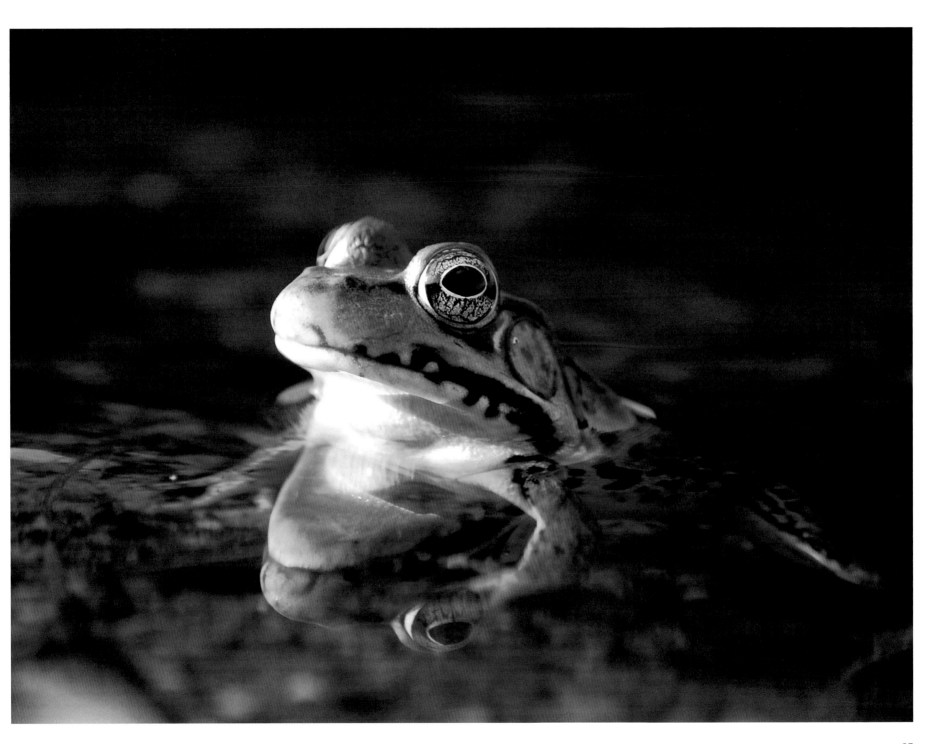

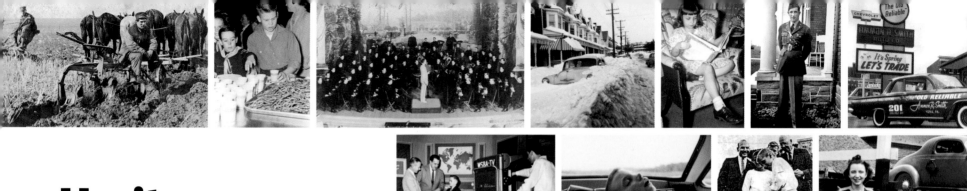

Heritage

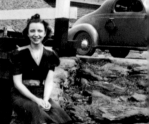

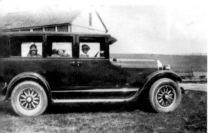
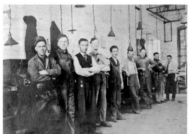
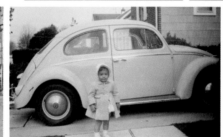

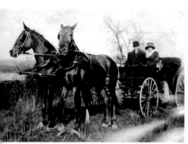
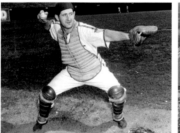
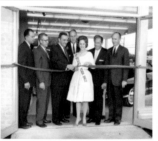
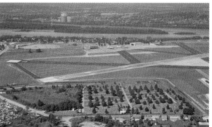
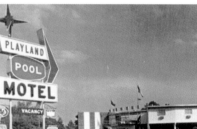

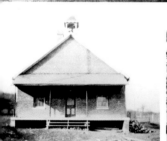

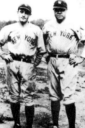
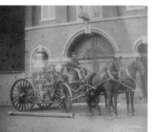

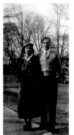

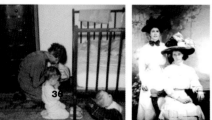

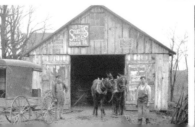

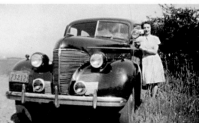

36

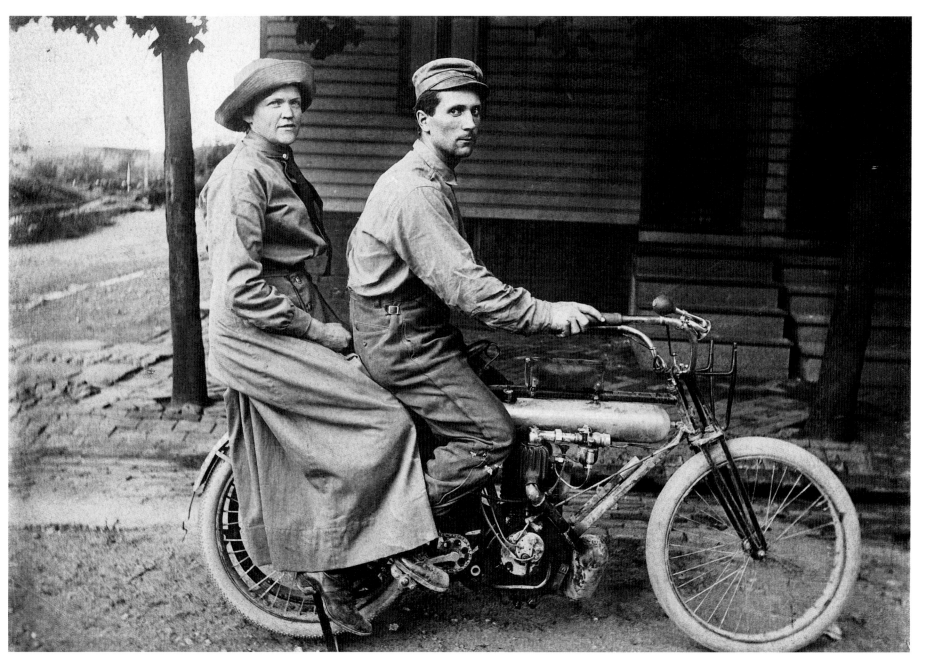

EARLY RIDE: Family photo of my great-grandfather, Franklin Armold, and his wife Lillian while out for a motorcycle ride in the 1920s. 📷 AMY STAUB

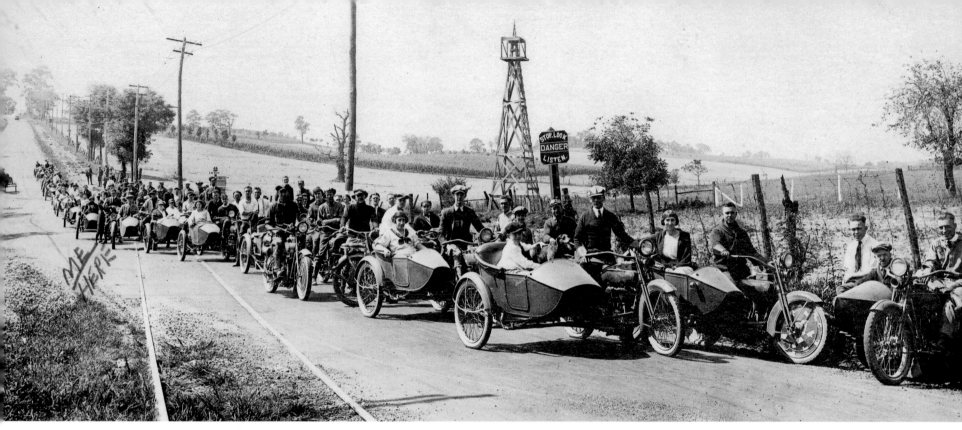

ROAD TRIP: *(above)* A motorcycle ride my grandfather participated in during the 1920s. 📷 AMY STAUB

CHARLES S. RISHEL *(right):* Charles Rishel takes the reins of the open/courting buggy near his family farm in Emigsville, PA, before 1920. 📷 DIANNE BOWDERS

AMERICAN GOTHIC *(opposite left):* My grandparents pose in a new version of *American Gothic*, with a groundhog killed on their Manchester Twp. farm. Note: Photo taken circa 1914, from our family photo album. 📷 DIANNE BOWDERS

CITIZEN'S BAND *(opposite top):* Photo of the North York Citizen's Band taken in the 1920s. 📷 AMY STAUB

GO CART *(opposite bottom):* Even at 2 years of age I was already interested in old cars. 📷 STEVE SMITH

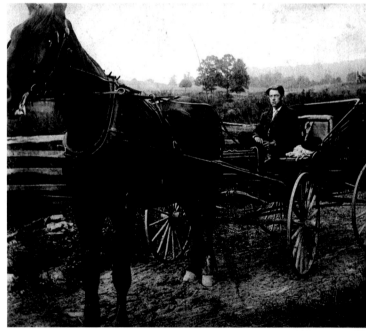

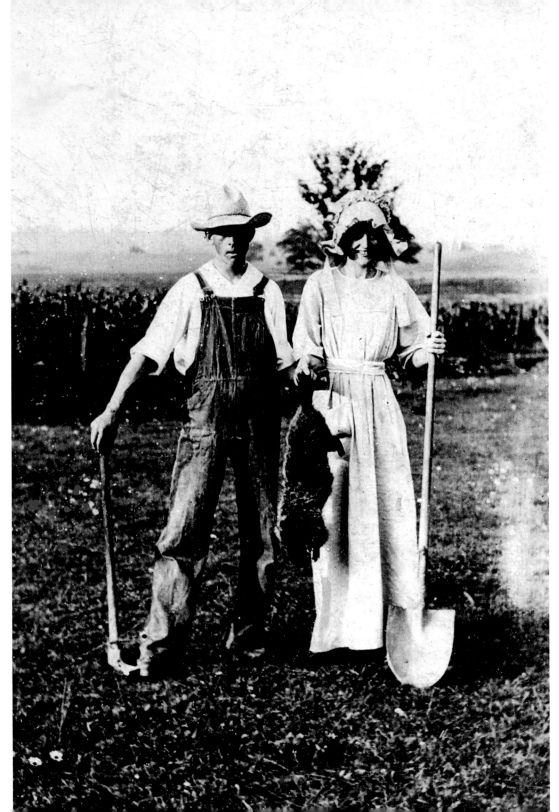

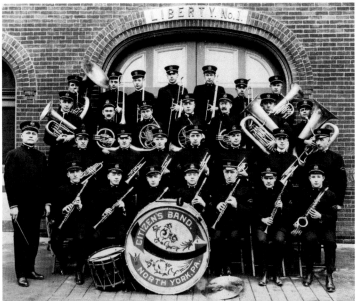

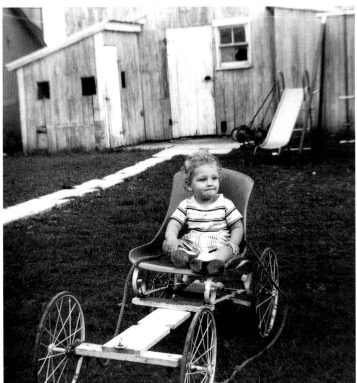

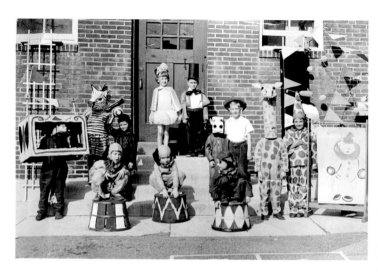

UNTITLED (above): Ready to perform under the big top, students at the Second Arch Street Public School celebrate May Day 1952.
📷 PAUL KUEHNEL/INYORK.COM

UNTITLED (right): Stewart E. Lauer, president of York Ice Machinery Corporation, stands on the bed of a truck to inform employees of their role in the Allied war effort shortly after the attack on Pearl Harbor. Company newsletter *Cold Magic* summarized the scene: 'The Boss explains a few things, tells us we're on the front line of war industry . . . what our daily work means in fighting terms.' York Ice Machinery became York Corporation later in the war. 📷 YORK HERITAGE TRUST

UNTITLED (opposite): Brenneman's School 1950. Brenneman's School is located on the road from Yorkanna to Mt. Pisgah and sits next to the former Gusts orchards. As far as we can tell, the school was built in the late 1870s and used up to January 1955 when the new Canadochly Elementary School was opened. 📷 CLAIR WENTZ

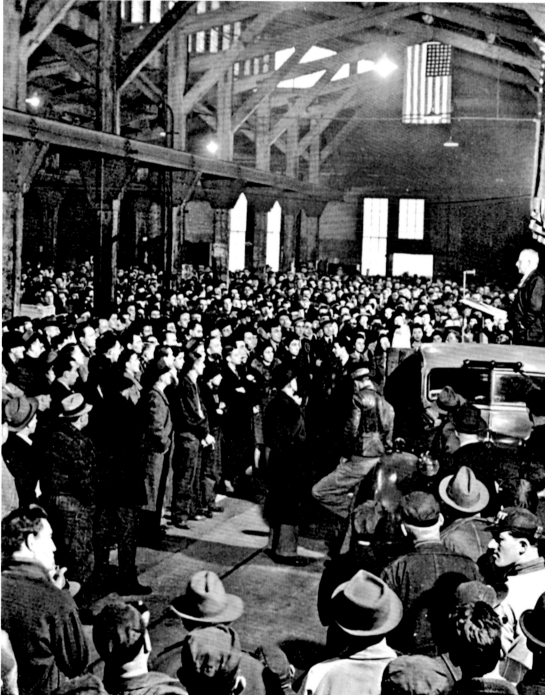

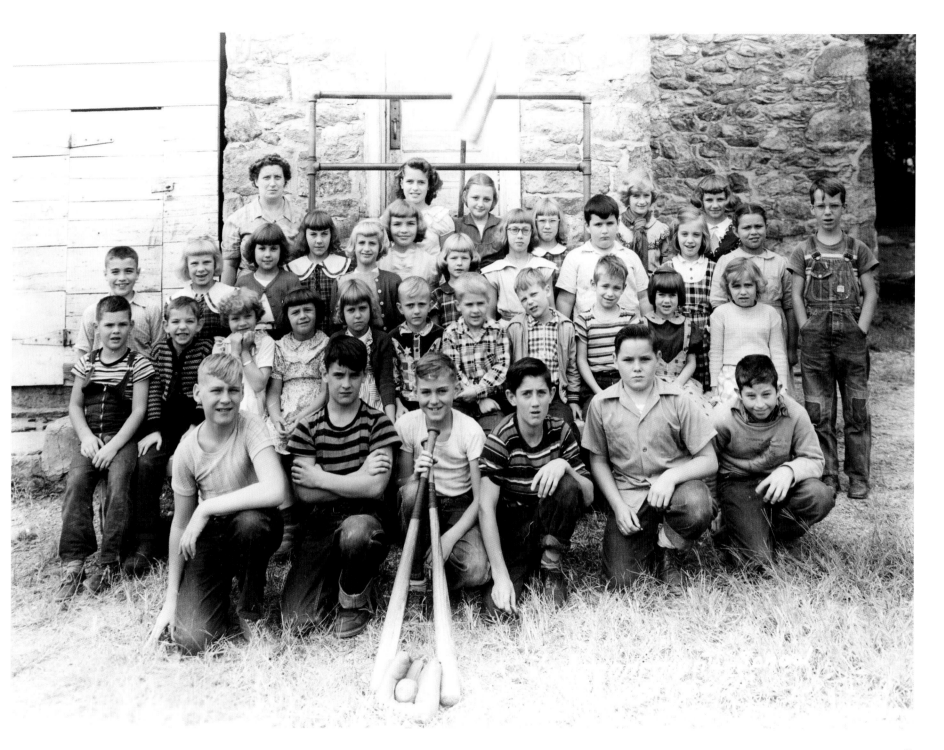

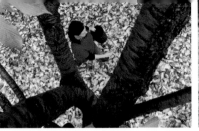

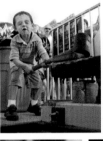
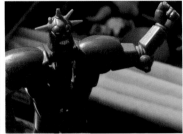

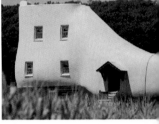

Everyday Life

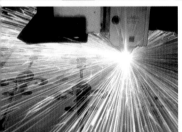
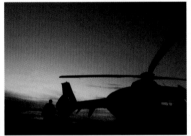

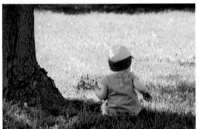

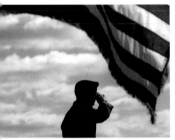

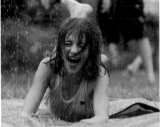

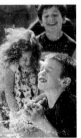
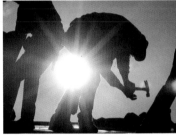

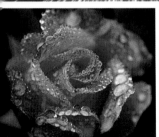
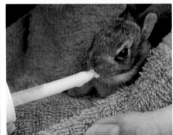
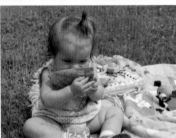
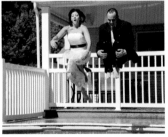
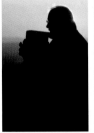
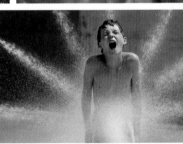

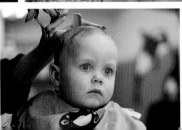

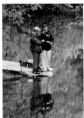
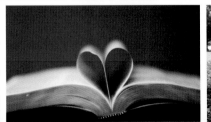

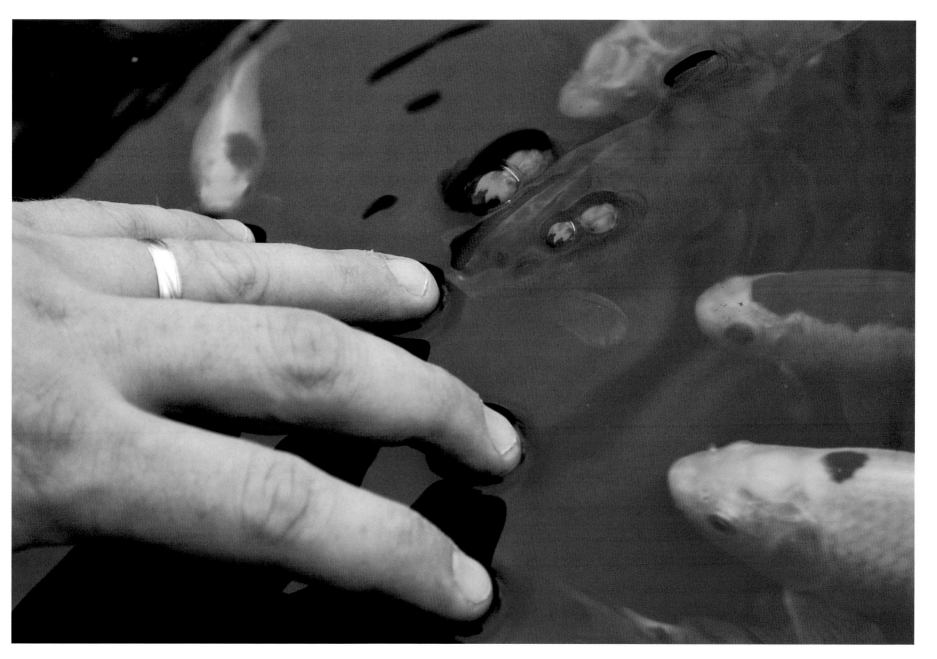

TOUCHING NATURE: Feeding our pond fish is most enjoyable. Photo taken: York, PA.
JENNIFER BORROR

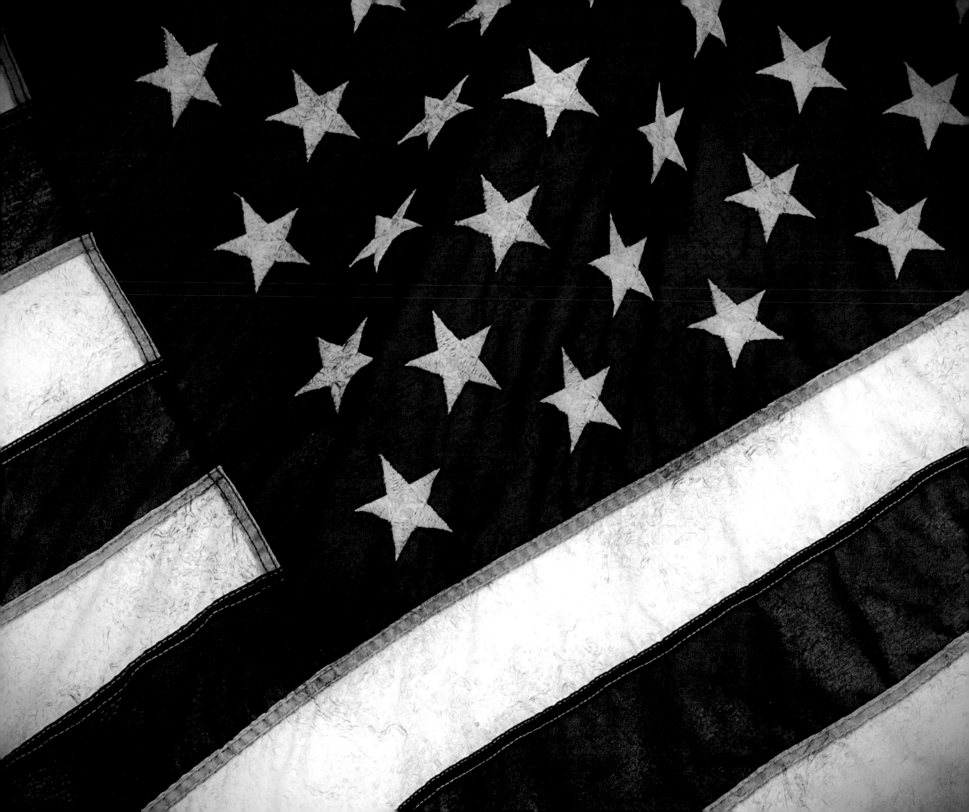

HAMBURGERS & HOT DOGS

ITALIAN CHOP STEAKS WITH CHEESE and SAUCE

SAUSAGE SANDWICHES WITH PEPPERS and ONIONS

Cold DRINKS

BREADED SEAFOOD SANDWICH

HAMBURGERS & HOT DOGS

Italian CHOP STEAKS

SAUSAGE SANDWICHES

BREADED CHICKEN SANDWICH

PEPSI DIET PEPSI

PEPSI DIET PEPSI Mt. DEW ROOT BEER ICED TEA

Sm $1.50 Med $2.00 Lg $3.00

★ **OLD GLORY** *(opposite):* Be a citizen activist... it's your birth-right and your duty.
📷 JULIANN LANGEHEINE

CHILDHOOD MEMORIES: This was taken at the Hot Air Balloon Festival at John Rudy County Park. Photo taken: John Rudy County Park. 📷 JANICE ZIMMER

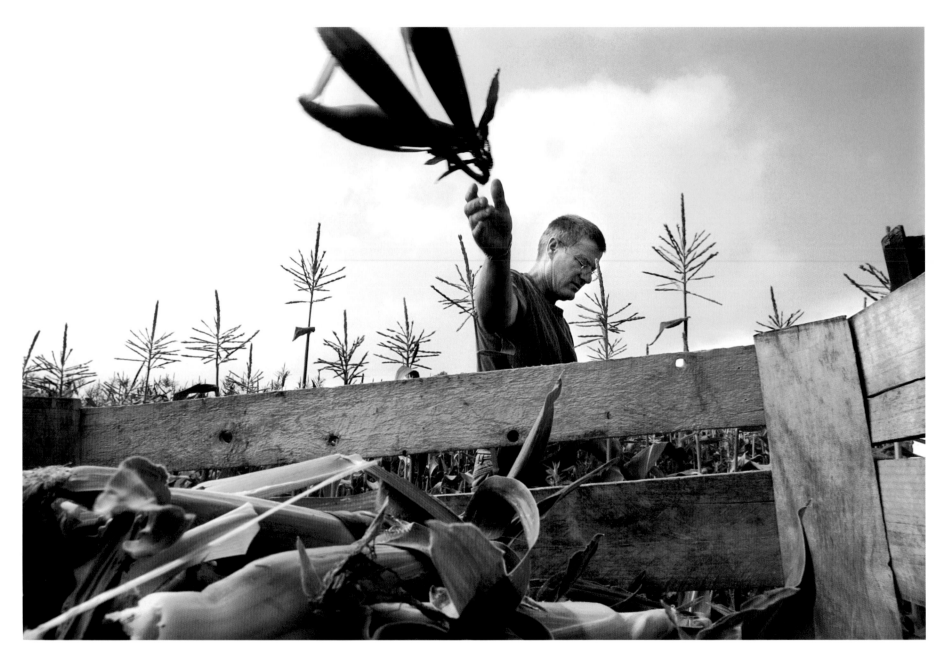

SWEET CORN: Swamp Fox Farm owner Steve Klesse throws a few ears of sweet corn into a bin while picking some of his early season corn. 📷 CHRISTOPHER GLASS/INYORK.COM

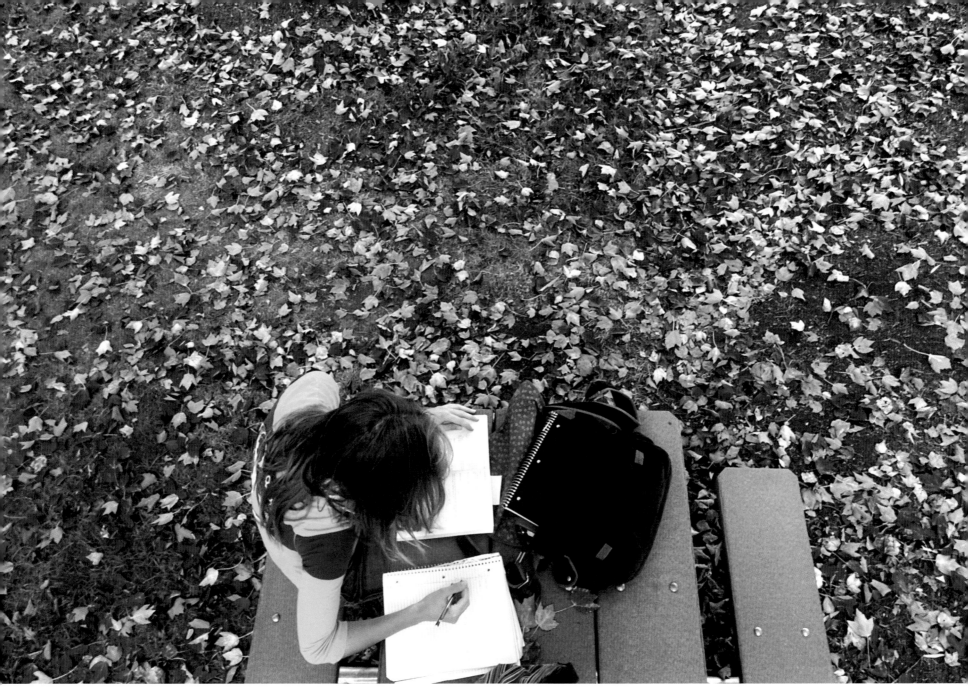

FALL LEAVES: York College fresh-man Mandy Parshall works at a picnic bench among the colorful fallen leaves.
📷 JASON PLOTKIN/INYORK.COM

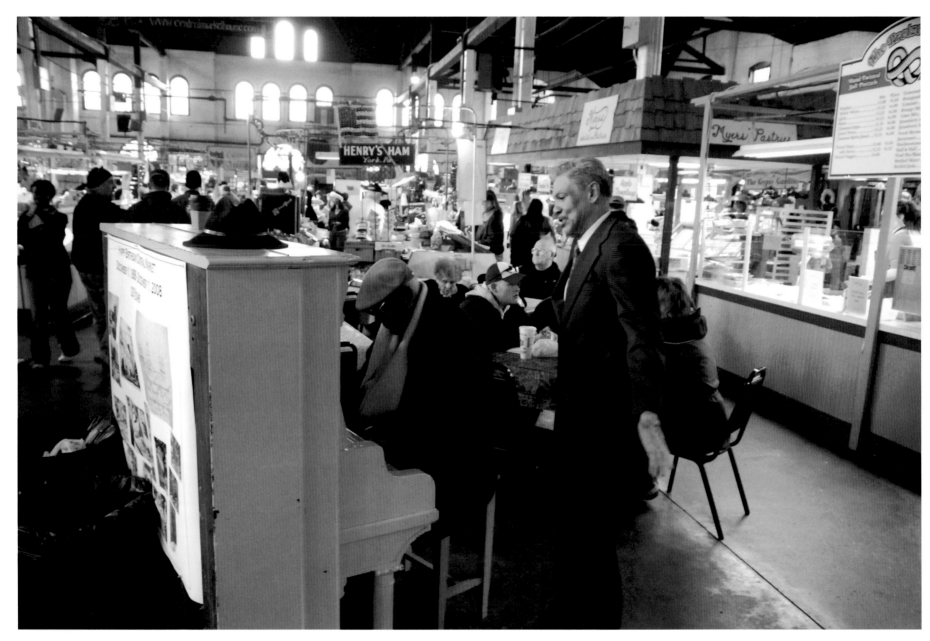

HOLIDAY TUNES AT CENTRAL MARKET: Two local gentlemen playing the piano and singing Christmas songs during a busy Saturday at Central Market. Photo taken: Central Market- Phila. and Beaver Sts.
📷 MIKE INKROTE

UNTITLED *(opposite left):* Family fun at the park. Photo taken: York Township Park, Oak Street. 📷 LYLA HESS

A SEAMSTRESS' RAINBOW *(opposite right):* My eye was drawn to this piece of art on the wall in the alterations room at David's Bridal. Photo taken: York, PA. 📷 TRINITY WALKER

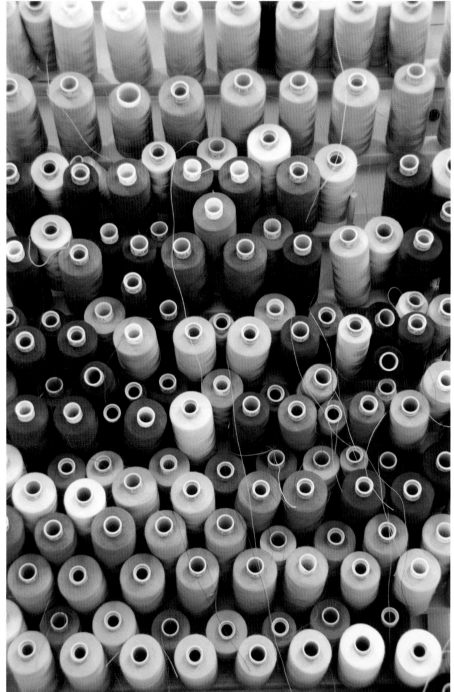

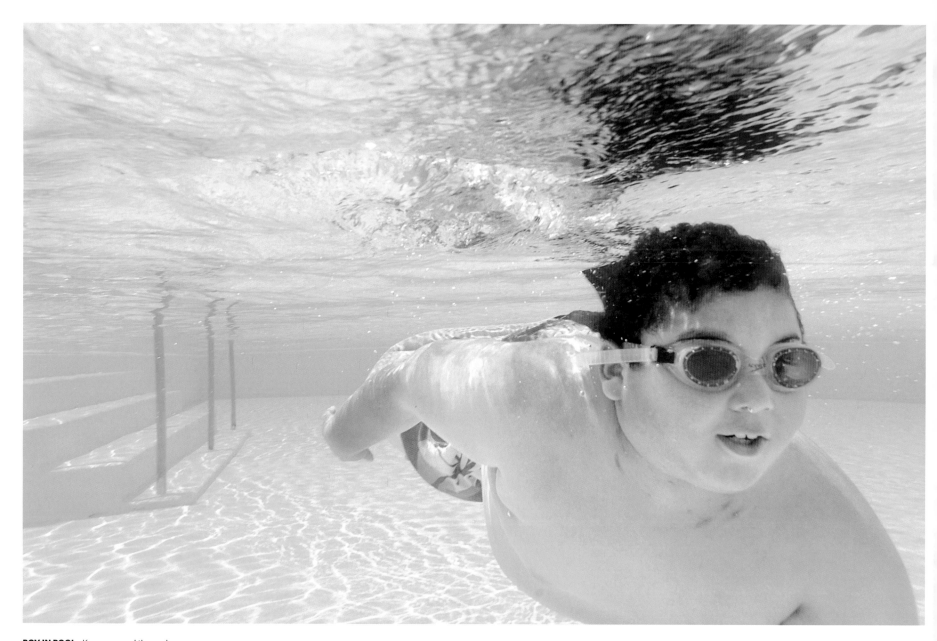

BOY IN POOL: Known around the pool as 'Sharkboy,' Richard Lossier, 10, cruises the shallow end of the Green Valley swimming pool in West Manchester Township. A few kids braved the 66-degree water as pool season officially began around the area.
📷 CHRISTOPHER GLASS/INYORK.COM

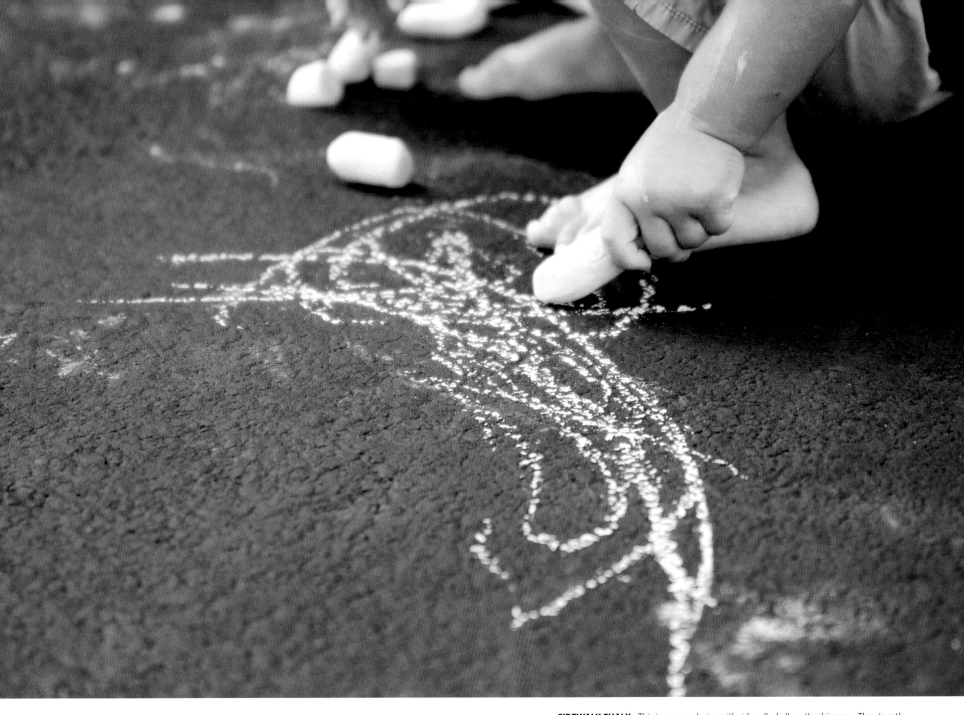

SIDEWALK CHALK: This is my son playing with sidewalk chalk on the driveway. There's nothing cuter than chubby little chalk-covered hands. Photo taken: My driveway. 📷 CHRISTINE HSIEH

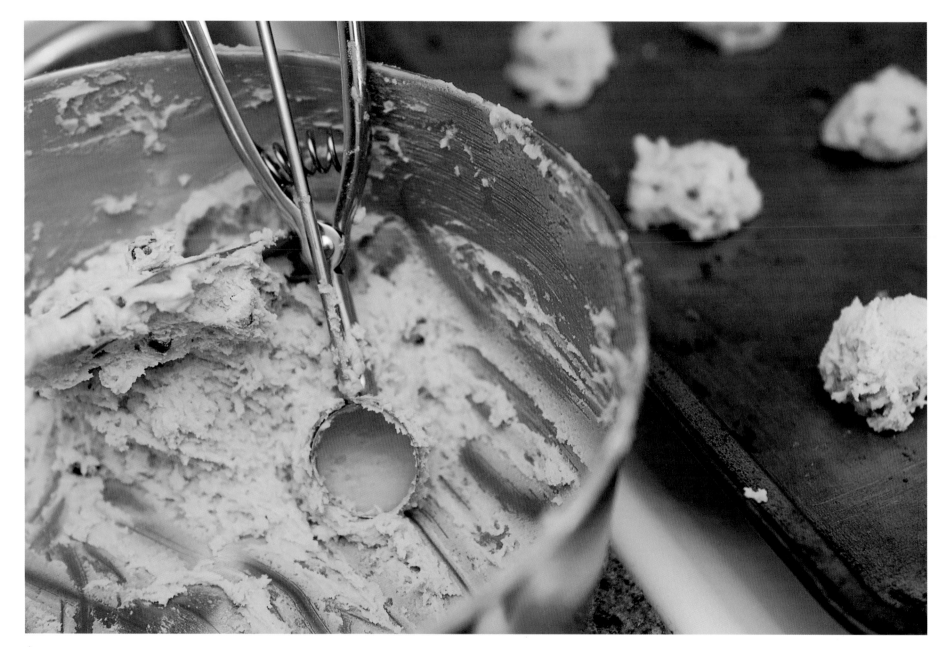

★ **CHOCOLATE CHIP COOKIES!:** The last time I made chocolate chip cookies I decided to get out my camera and snap a few shots. Yummy! Photo taken: My kitchen.
📷 CHRISTINE HSIEH

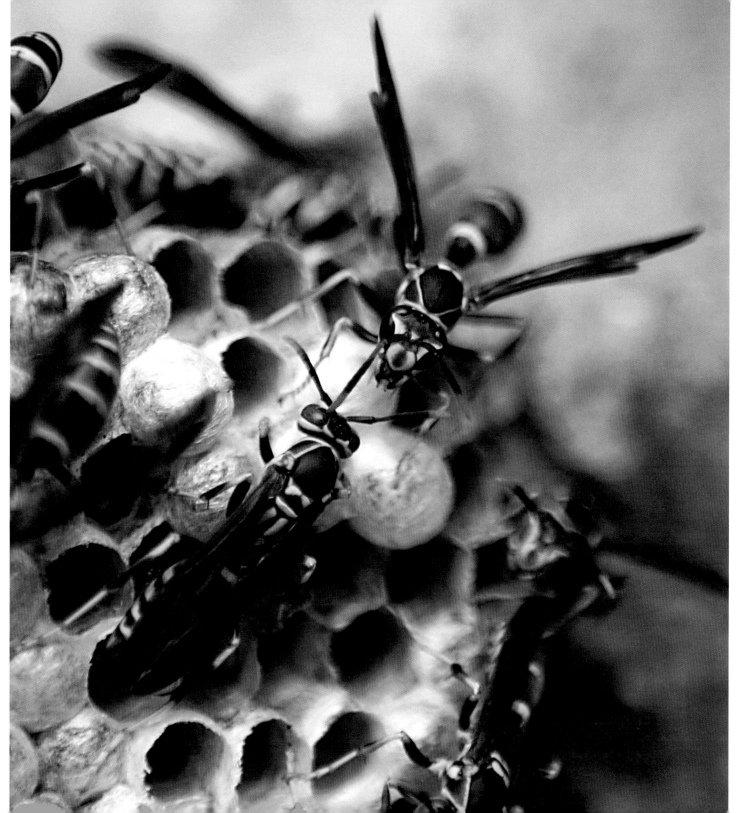

UNDER CONSTRUCTION: Wasps working on their nest. Photo taken: Red Lion.
📷 JANICE ZIMMER

Scapes of All Sorts

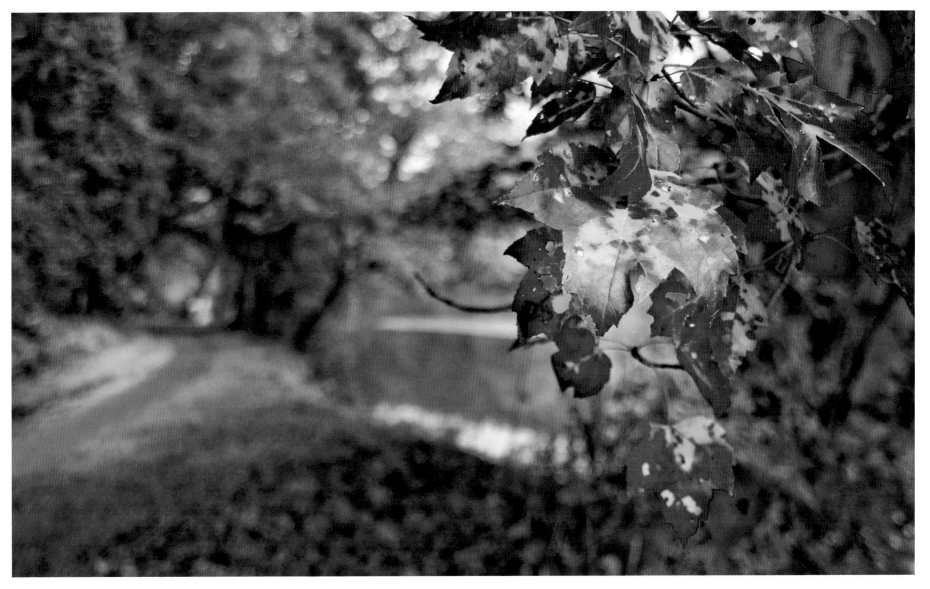

FIRST SIGN OF AUTUMN: Maple leaves were the first to turn color along this path by Lake Williams. Photo taken: William Kain Park. 📷 DWIGHT NADIG

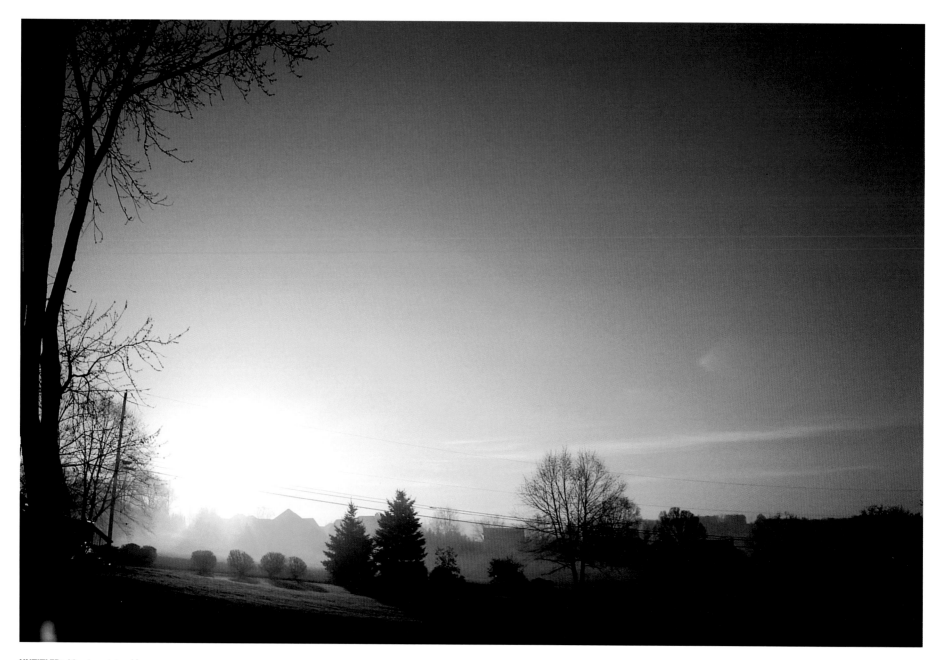

UNTITLED: Morning mist and fog are extraordinary on a seemingly ordinary day. Photo taken: York Township.
📷 DIANNE BOWDERS

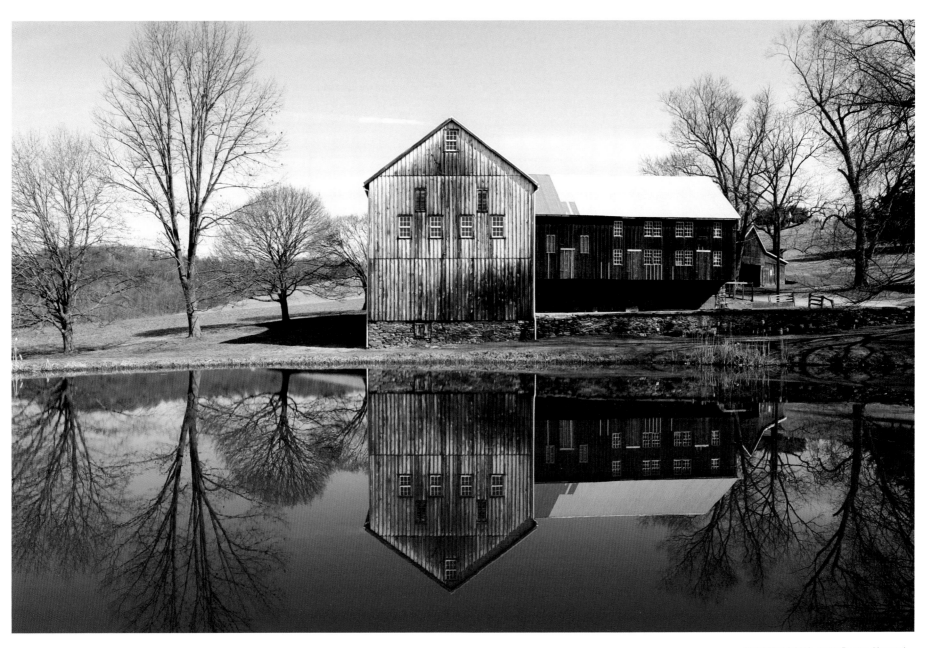

PEACEFUL BARN: Just reflecting. Photo taken: Hess Farm Road. 📷 SUSAN MASENHEIMER

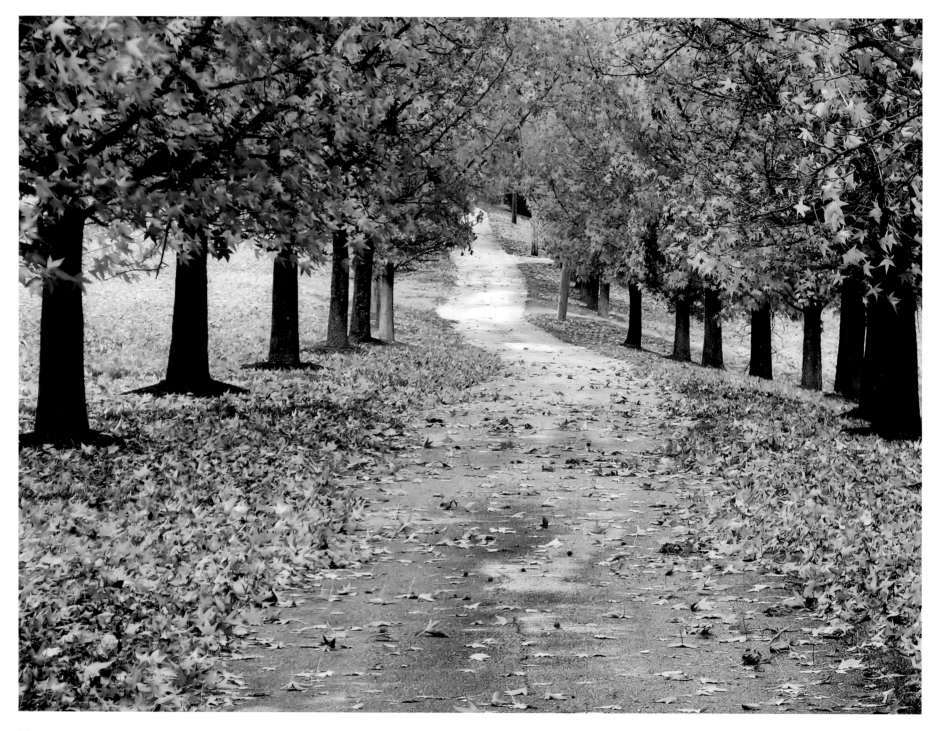

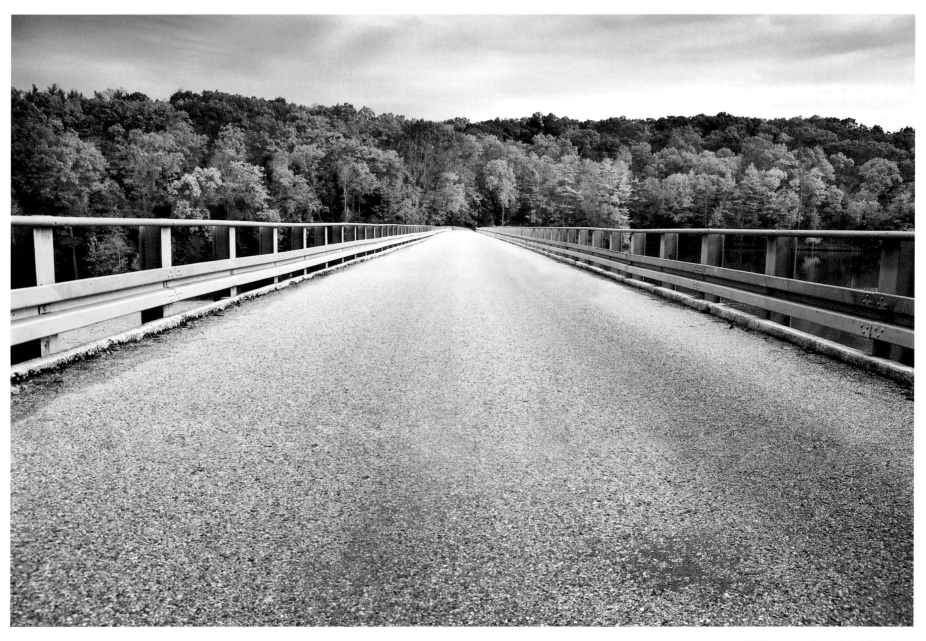

LITTLE LANE *(opposite):* A fall scene of a lane leading into a home along Glatfelter's Station Road. 📷 DEB PACKARD

UNTITLED: Crossing the Lake Williams Dam in autumn. Photo taken: William Kain Park. 📷 DWIGHT NADIG

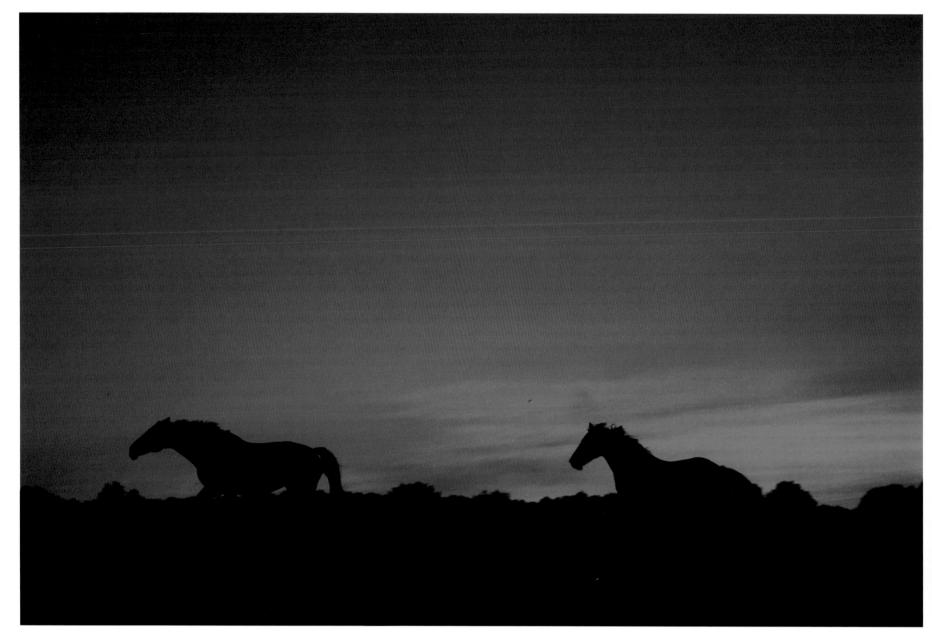

SUNSET: Sunset in Southern York County. Photo taken: Stewartstown, PA.
📷 LAUREN LLOYD

★ **UNTITLED** *(opposite):* Taken on an early fall morning while overlooking farmland with fog in the valleys. Photo taken: Seven Valleys.
📷 MELANIE WALLACE

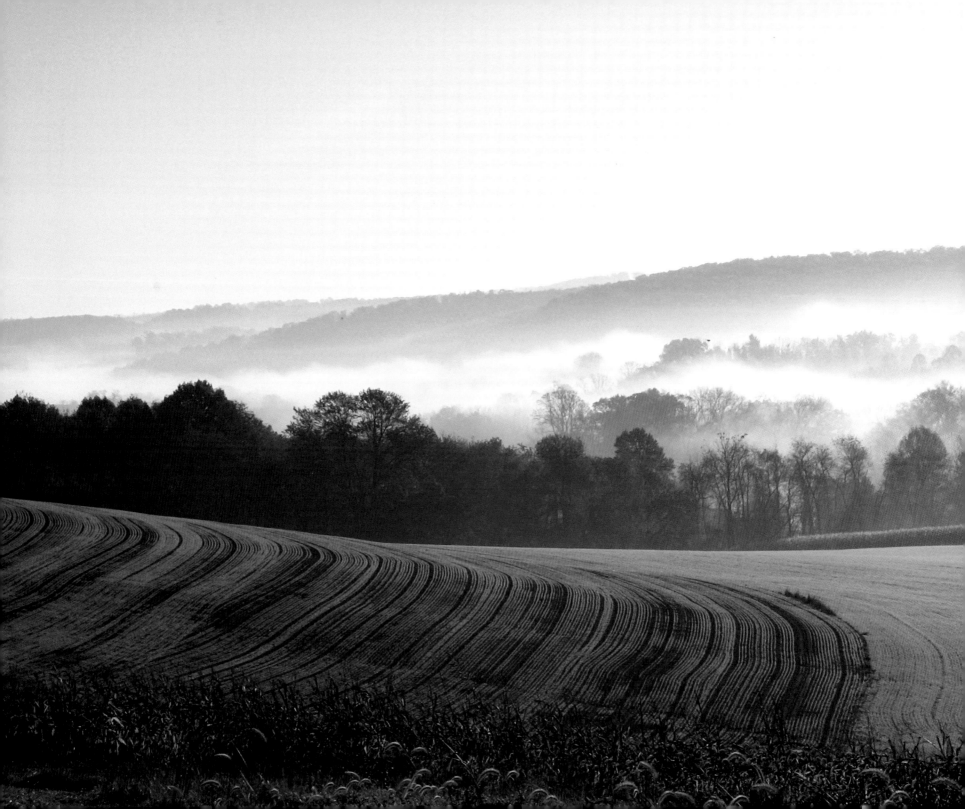

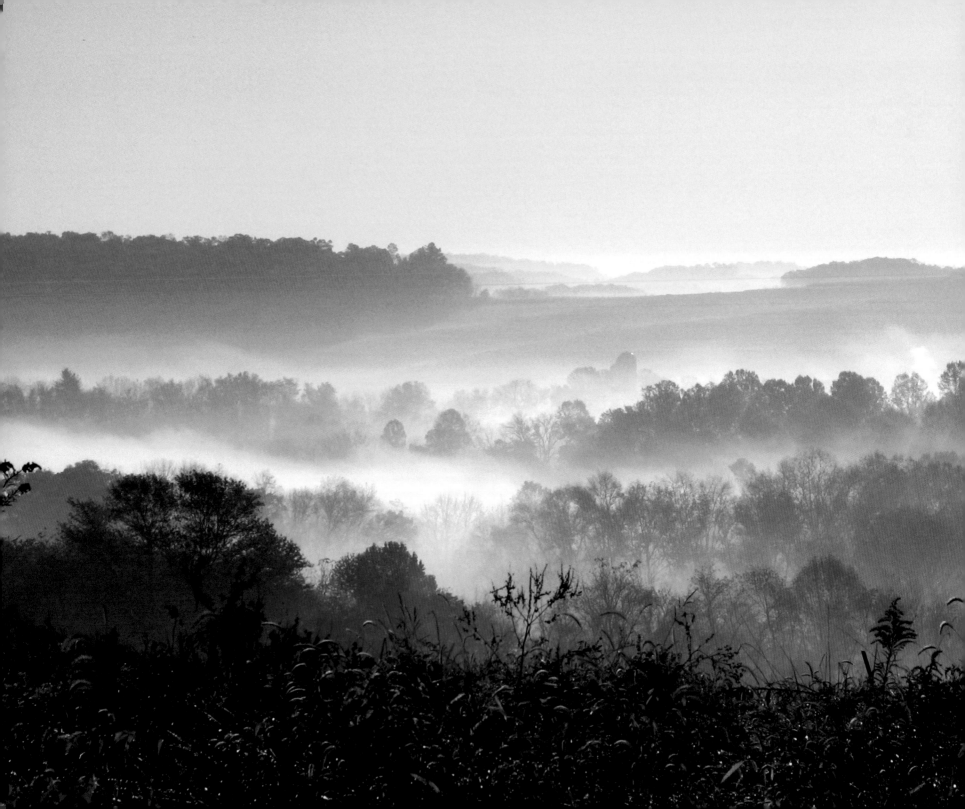

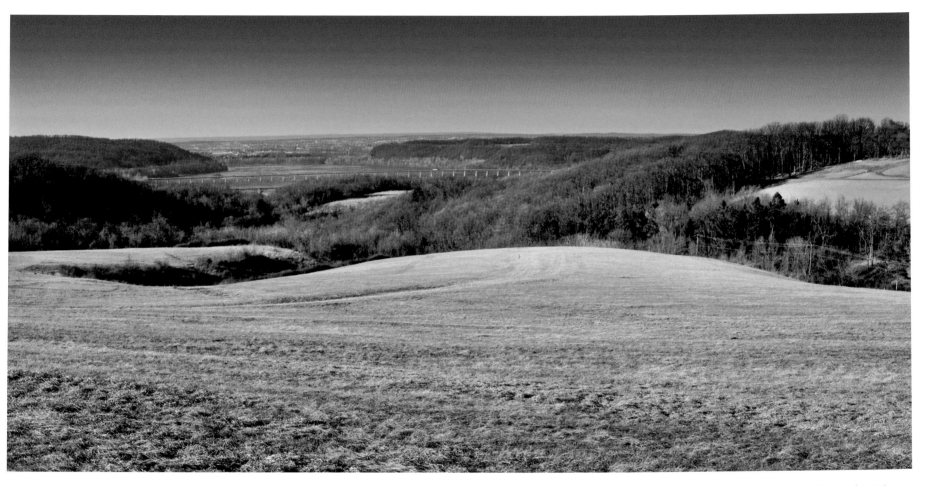

FOGGY DAY (*opposite*): Overlooking hills and farmland in Seven Valleys on a foggy early morning. Photo taken: Seven Valleys. ◙ MELANIE WALLACE

UNDULATING: North-to-northwest view of the Susquehanna River Valley, Lower Windsor Township. Photo taken: Wrightsville, Pennsylvania. ◙ NICHOLAS A. TONELLI

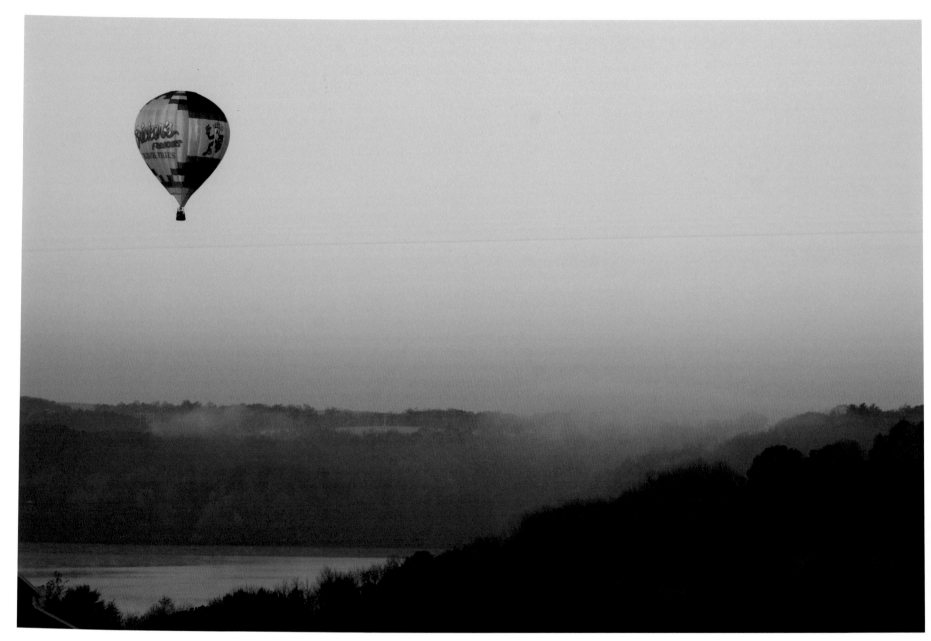

FALL BALLOON RIDE OVER LAKE REDMAN: Fall balloon ride over Lake Redman. Photo taken: Lake Redman, York, PA.
📷 INK BYERS

AUTUMN MORNING MIST *(opposite):* Early morning at Gifford Pinchot State Park is a great way to start the day off. Reminds you of the beauty life has to offer for the upcoming day. Photo taken: Gifford Pinchot State Park, Lewisberry, PA. 📷 JANICE BENDER

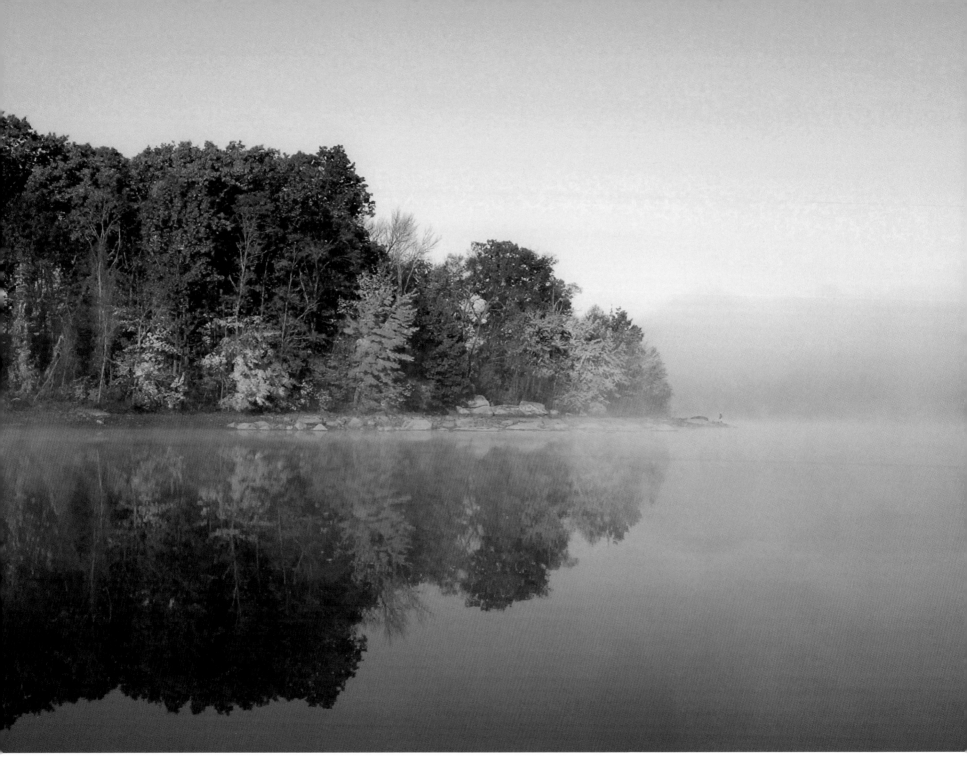

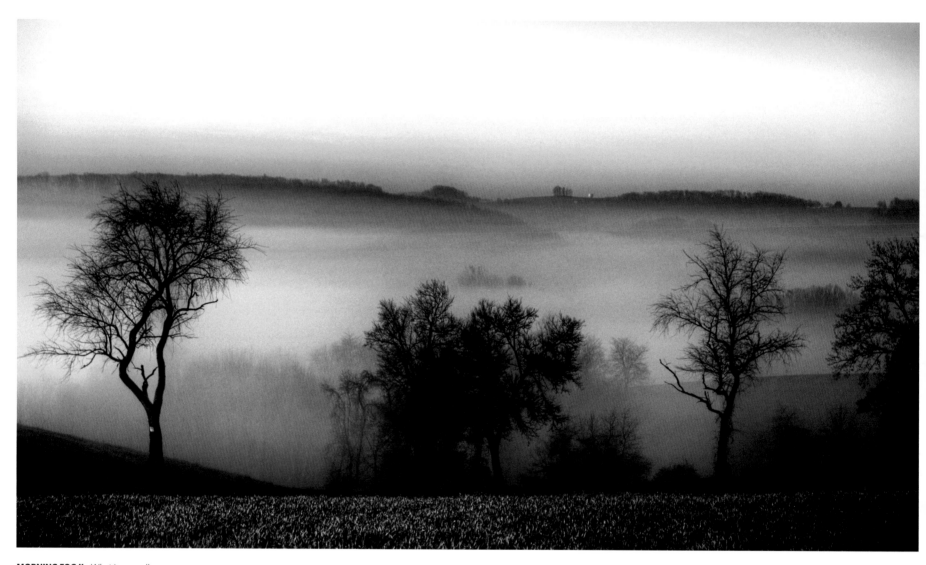

MORNING FOG II: What is normally a beautiful landscape turned into a landscape hidden in the fog. Photo taken: York.
📷 SHAWN HUBER

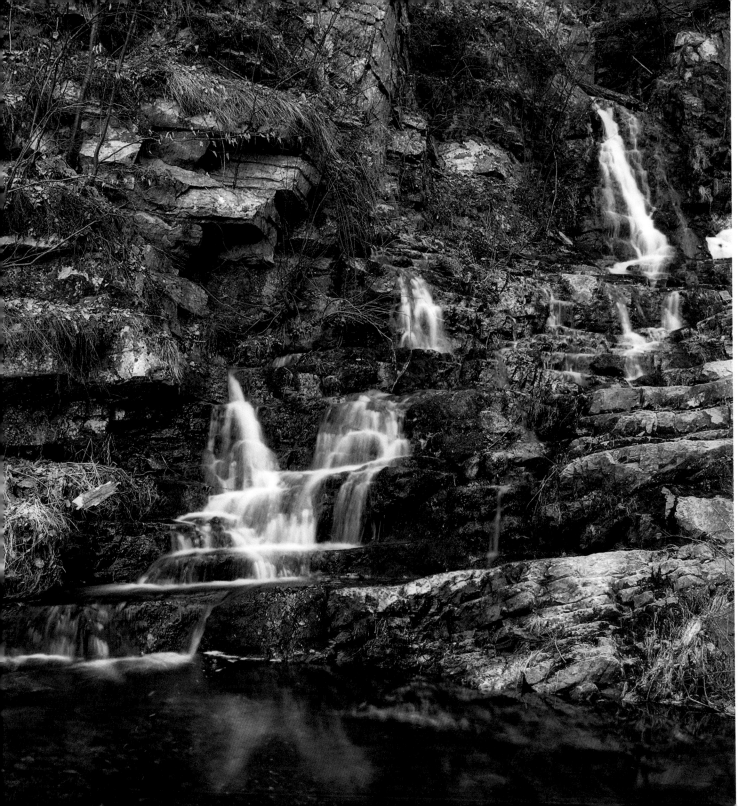

TIERED: Wildcat Falls. Remote and difficult to find, the falls cascade 20 to 25 feet (6 to 8 meters) from the Susquehanna River cliffs north of Wrightsville. Photo taken: Wrightsville, Pennsylvania.
◙ NICHOLAS A. TONELLI

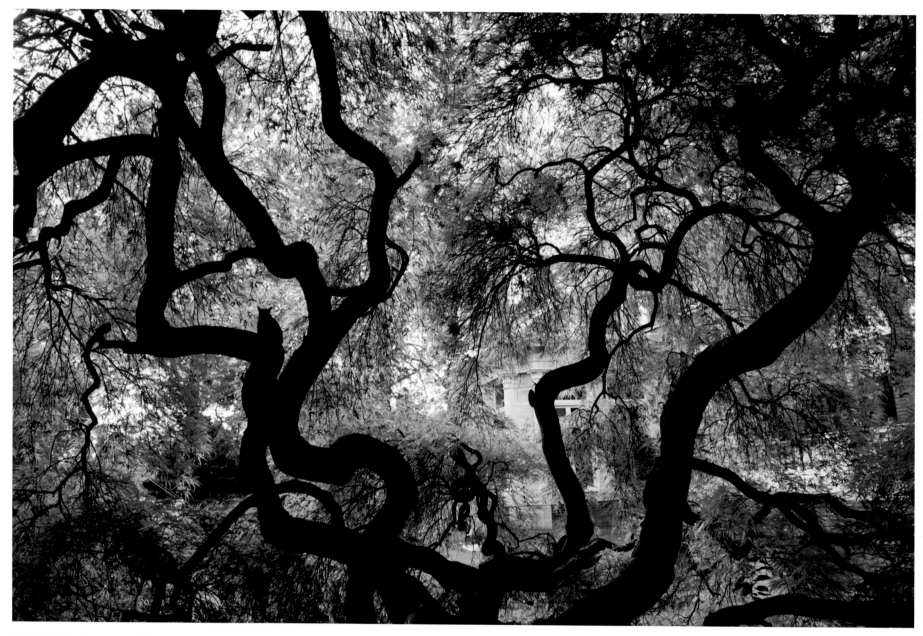

BURNING BUSH: Can you see me? Photo taken: Baltimore Street, Hanover, PA.
📷 SUSAN MASENHEIMER

⭐ **UNTITLED** *(opposite)*: Ceiling in the Gazebo in Farquhar Park. Photo taken: Farquhar Park. 📷 DWIGHT NADIG

72

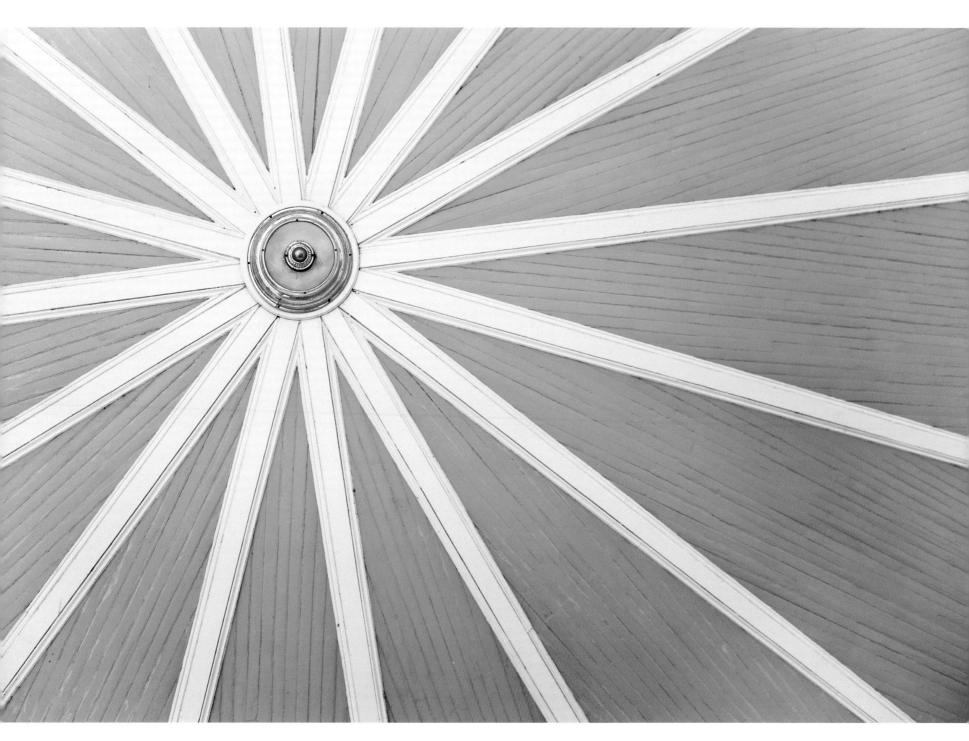

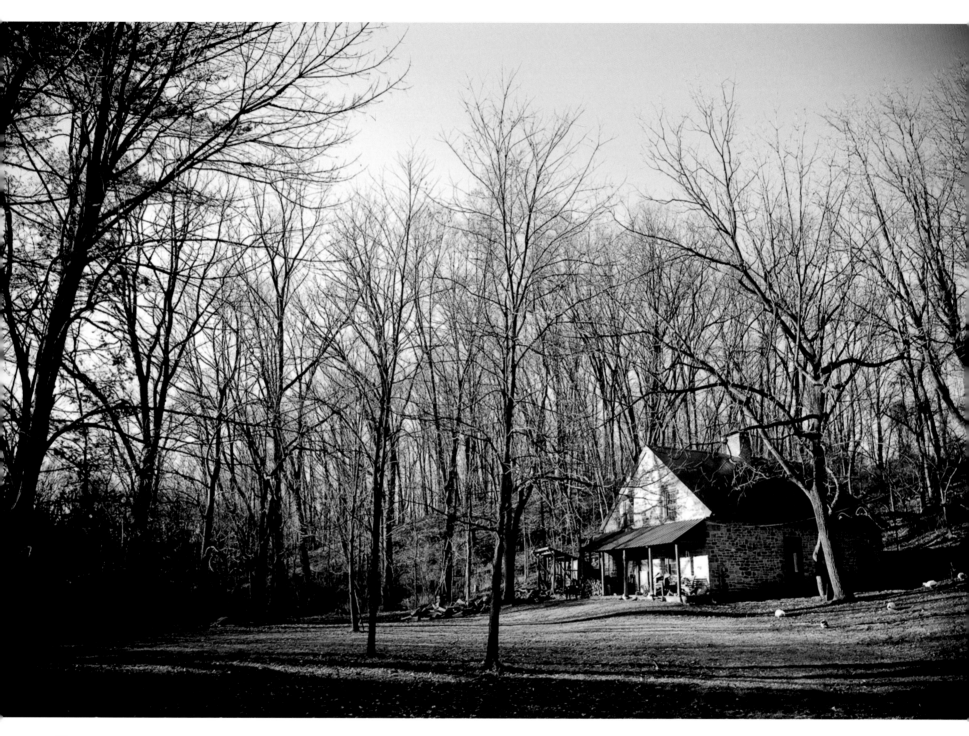

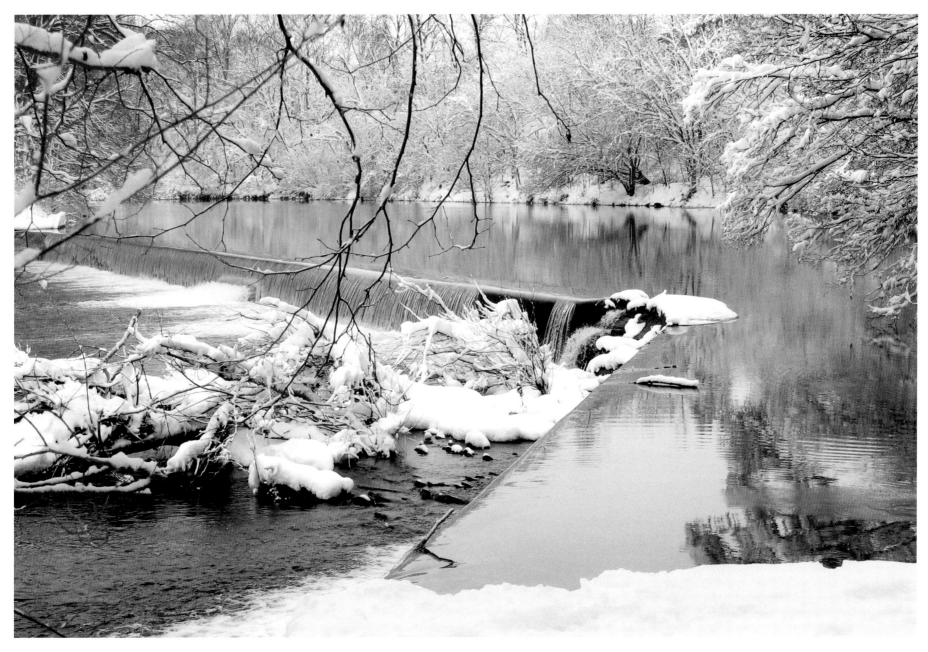

OVER THE RIVER *(opposite):* An old farm-house set in a clearing. Photo taken: York, Pennsylvania. 📷 BERNARD SIAO

WINTER AT CONEWAGO CREEK: A winter scene of the Conewago Creek near where I live. 📷 DEB PACKARD

UNTITLED: The sun breaking through the morning fog in the forest. Photo taken: William Kain County Park, by Lake Williams. 📷 DWIGHT NADIG

LAKE REDMAN II *(opposite):* Infrared shot. Backwaters of Lake Redman Photo taken: Lake Redman. 📷 JOE WAMSLEY

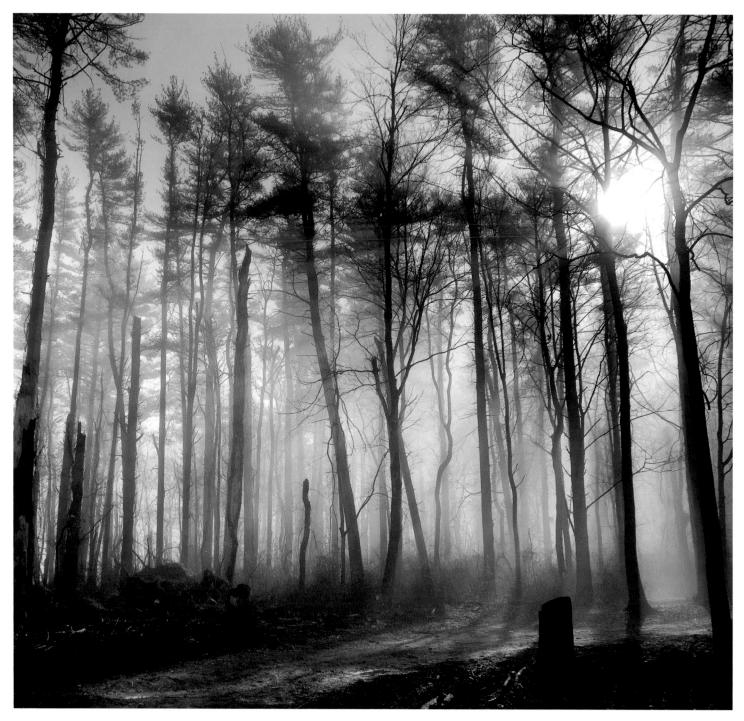

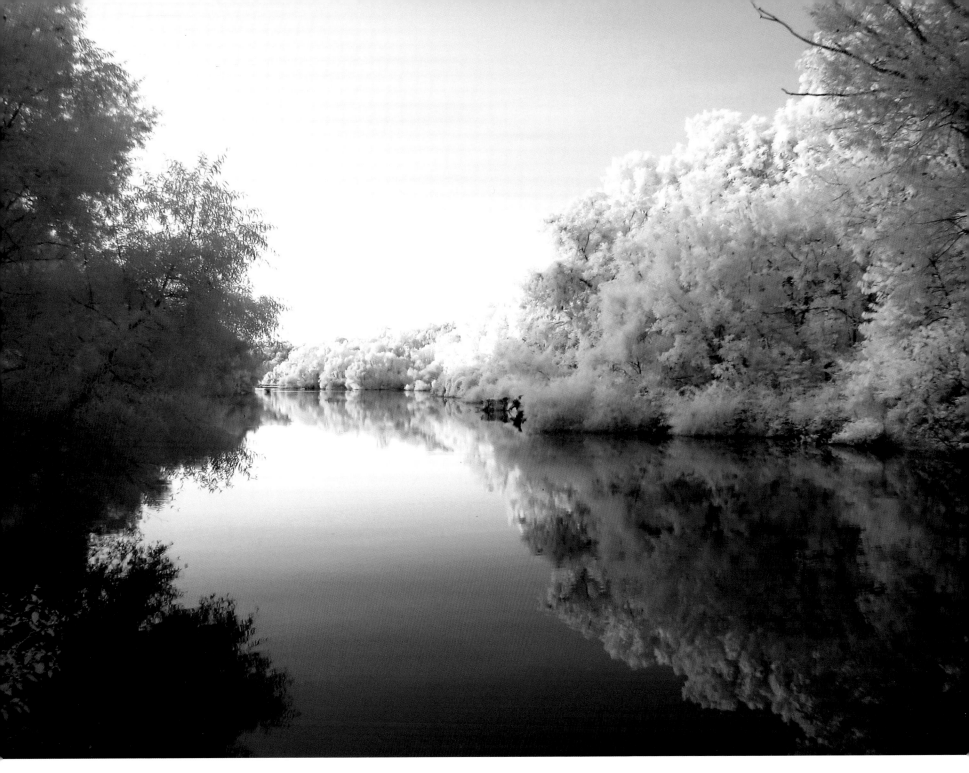

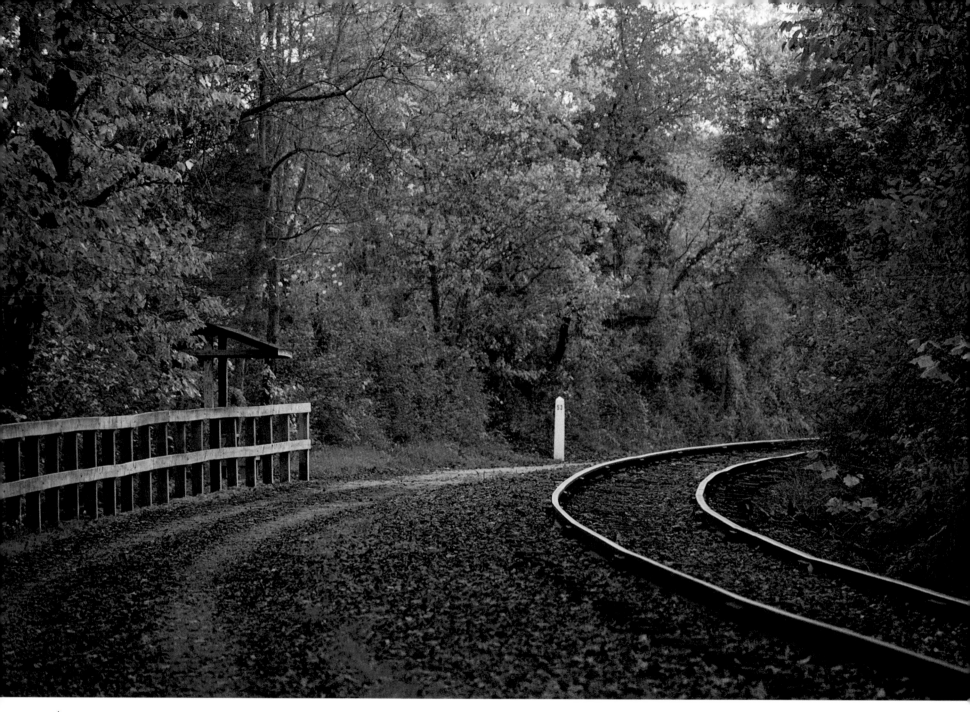

★ **JUST AROUND THE BEND:** York County
Rail Trail in autumn splendor. 📷 MARCY ROYCE

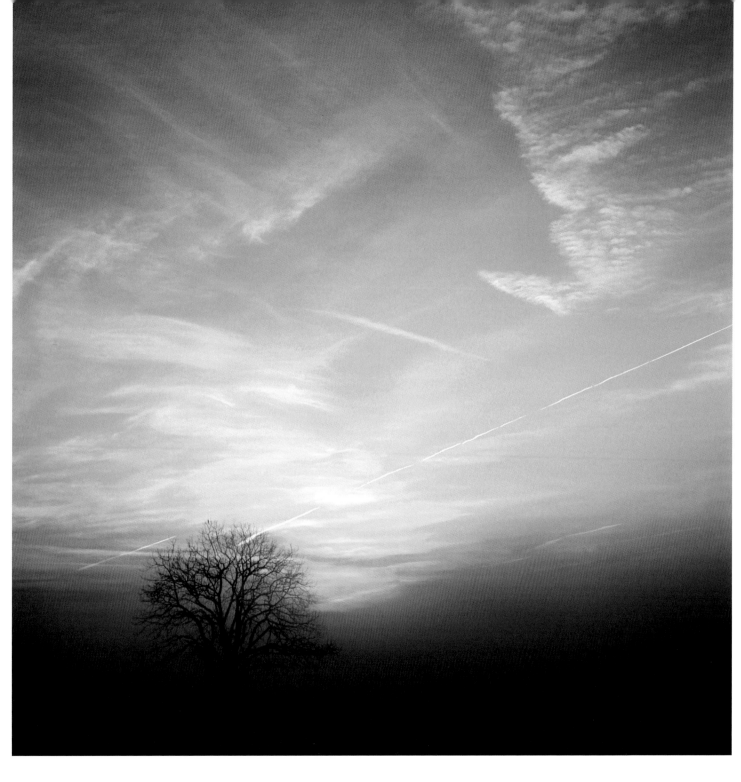

MORNING GLORY: Another morning on the way to school. The day wouldn't have been so good if I wasn't able to snap a few shots of the fog lingering in the field. The sun was just peeking up. It was a good start to a great day. Photo taken: Spring Grove, PA.
📷 PATRICK THOMAS

HEAVEN'S LIGHT II: Another beautiful sunset shot. Photo taken: York. 📷 SHAWN HUBER

CLOUDY SUNSET *(opposite):* One of the more beautiful golden sunsets overlooking Warrington Twp, PA. Photo taken: Warrington Twp, PA. 📷 JANICE BENDER

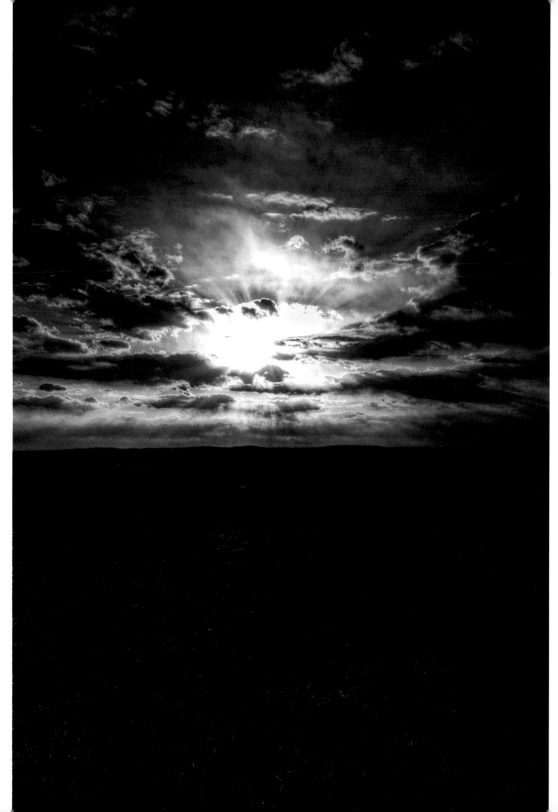

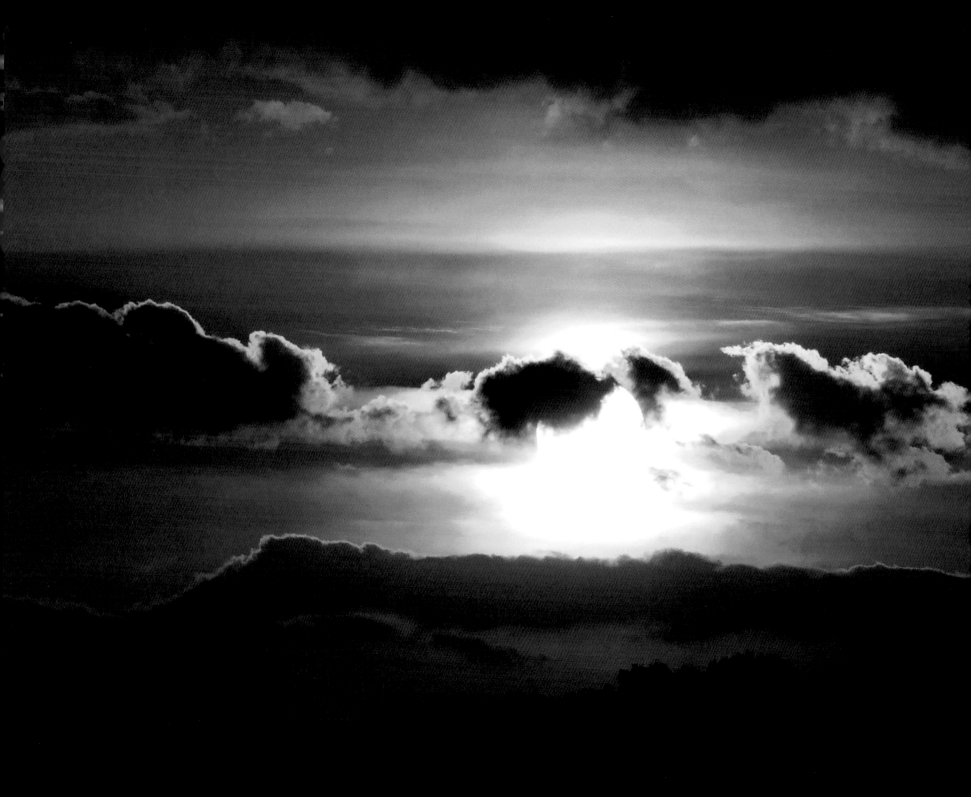

AUTUMN REFLECTION AT LAKE WILLIAMS: A beautiful autumn day in the park. Photo taken: William Kain County Park. 📷 DWIGHT NADIG

HEARTBEATS *(opposite):* Taken after a rainstorm with a Canon EOS 300D and a Sigma 70-300mm lens. Photo taken: York, PA. 📷 FRANK BELL

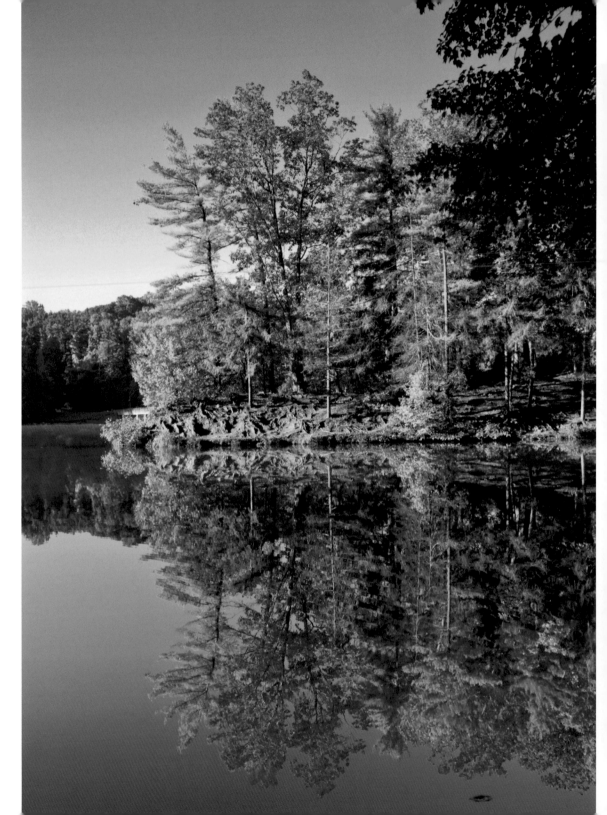

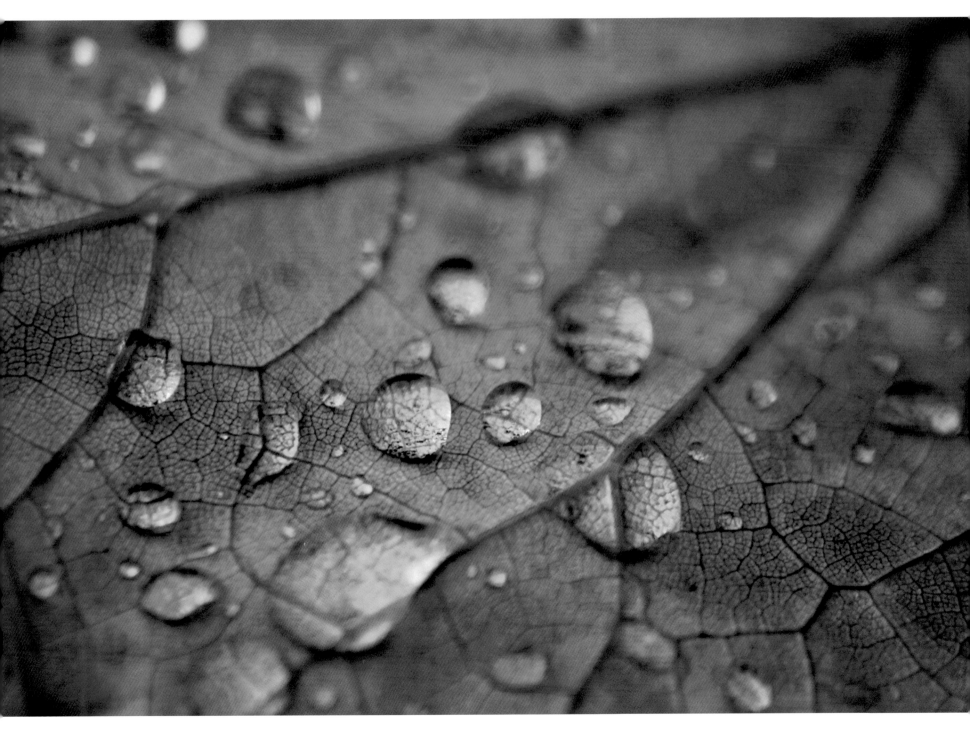

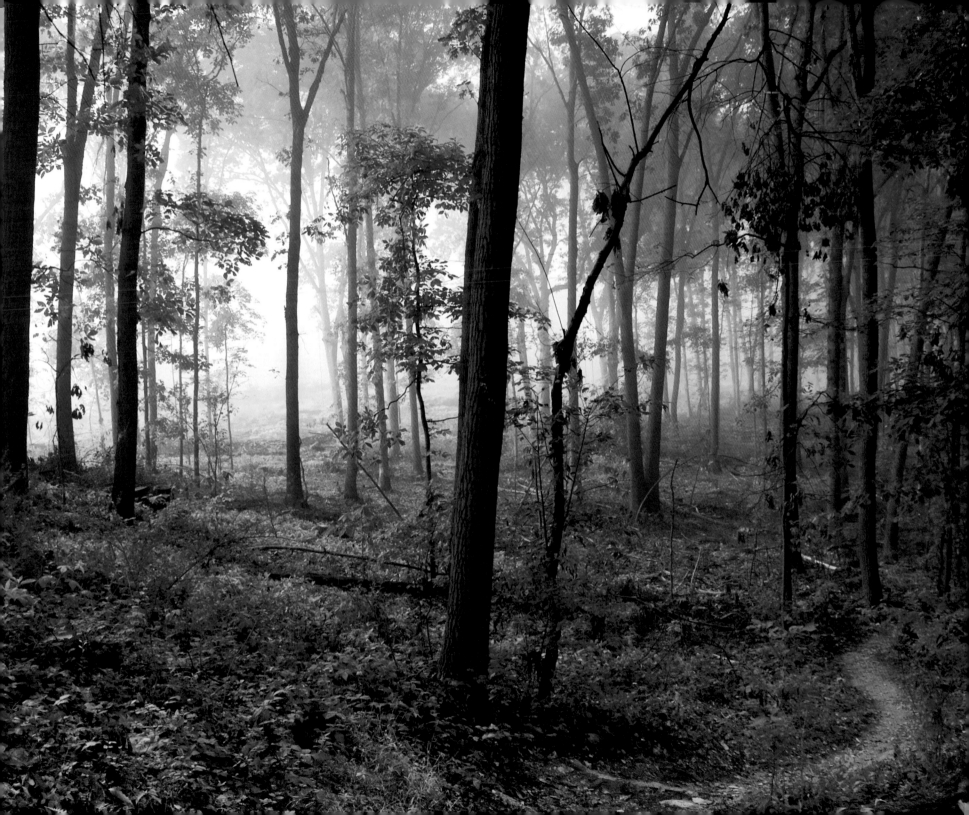

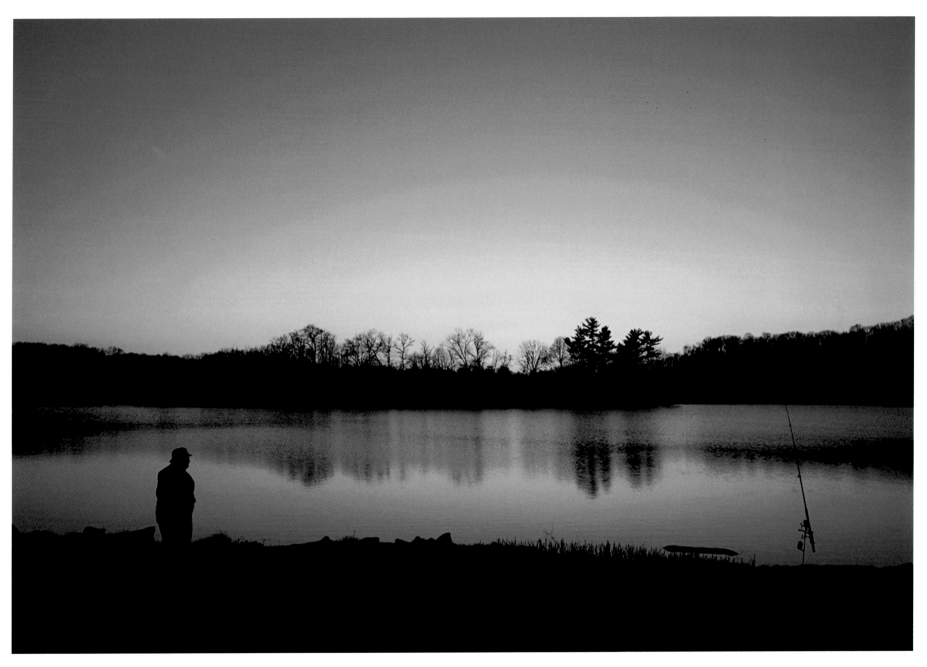

MISTY FOREST PATH *(opposite):* A forest path in William Kain Park, taken late last summer. Photo taken: William Kain Park. ◉ DWIGHT NADIG

MEN TOGETHER TODAY: Another taken at Lake Redman. Photo taken: Lake Redman, York, Pa.. ◉ FRANK BELL

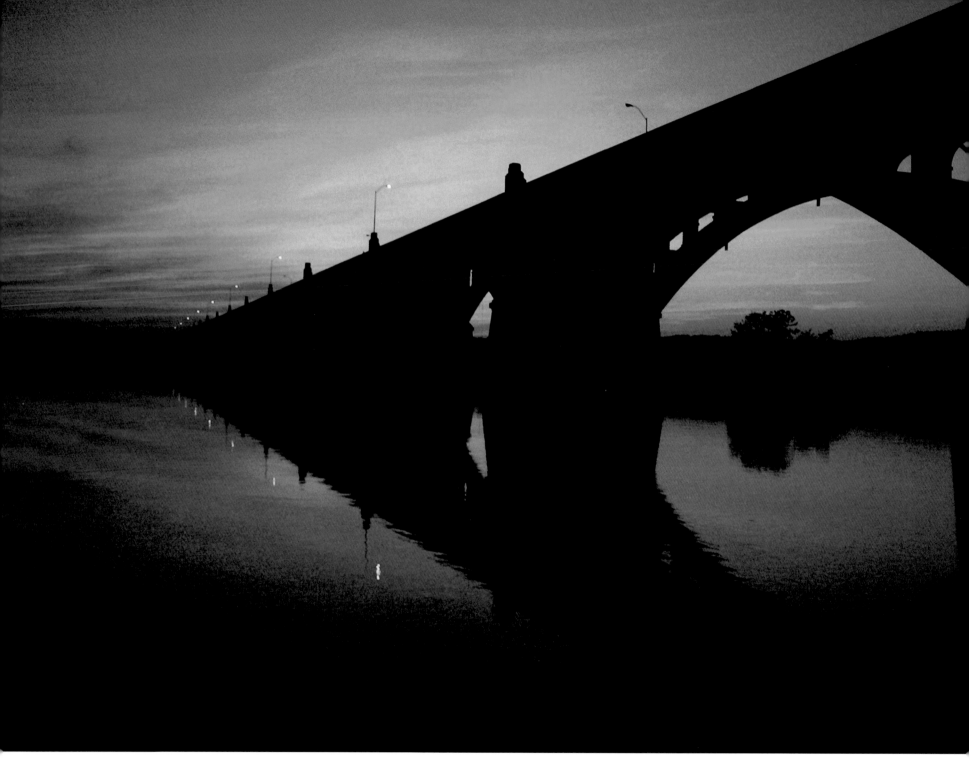

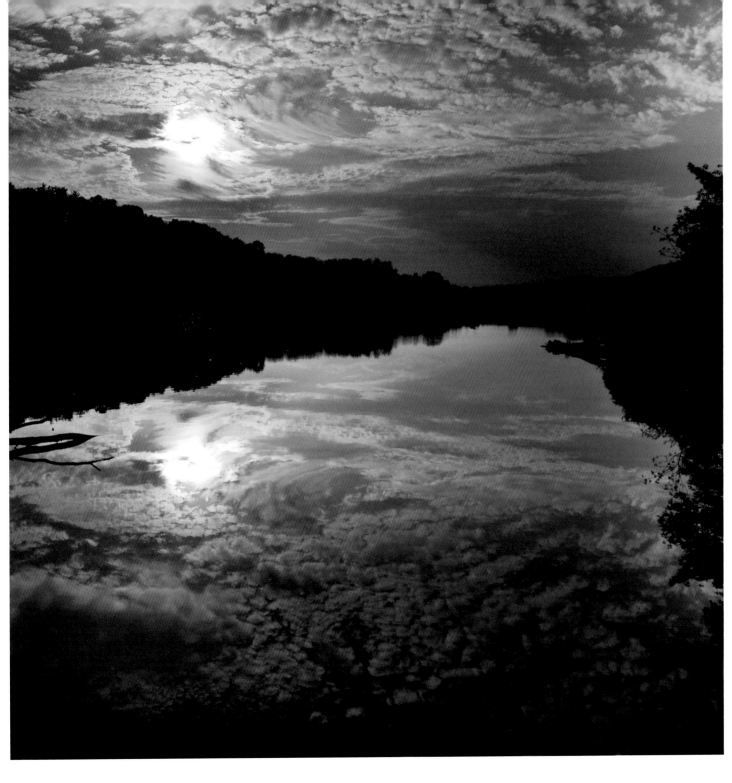

SUNSET REFLECTION: Another fabulous sunset on Lake Redman. Photo taken: William Kain Park. 📷 DWIGHT NADIG

AUTUMN SUNSET *(opposite):* Autumn sunset... Photo taken: Taken along the river on the Columbia side of the bridge. 📷 STEPHANIE BOYER

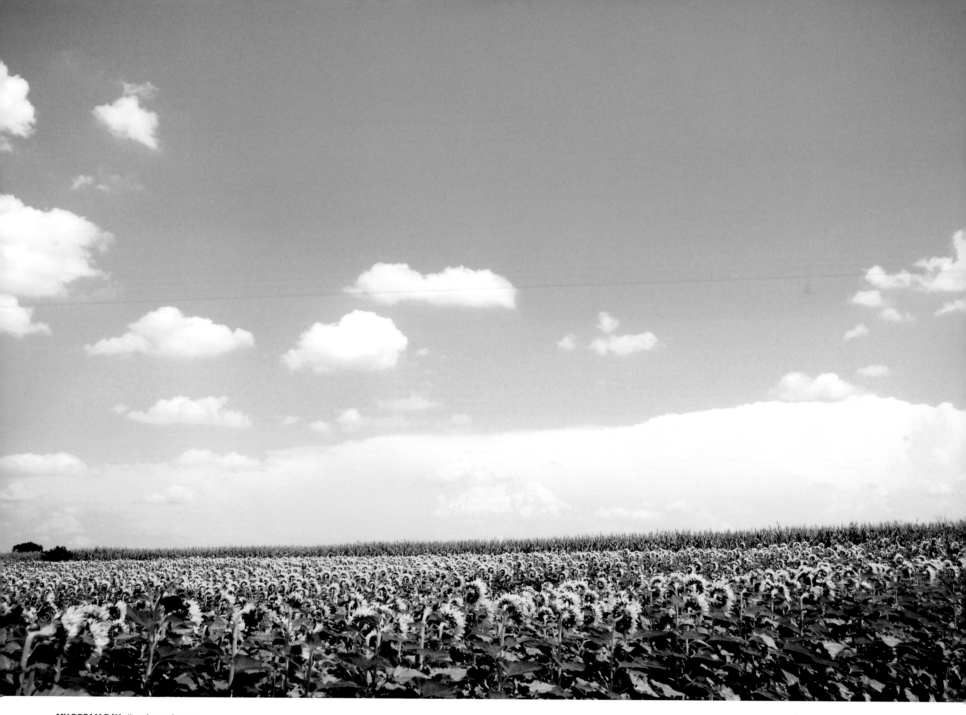

MY DREAM DAY: I've always dreamt
of running through a field of sunflowers,
finally I did! Photo taken: Manchester, PA.
📷 TRINITY WALKER

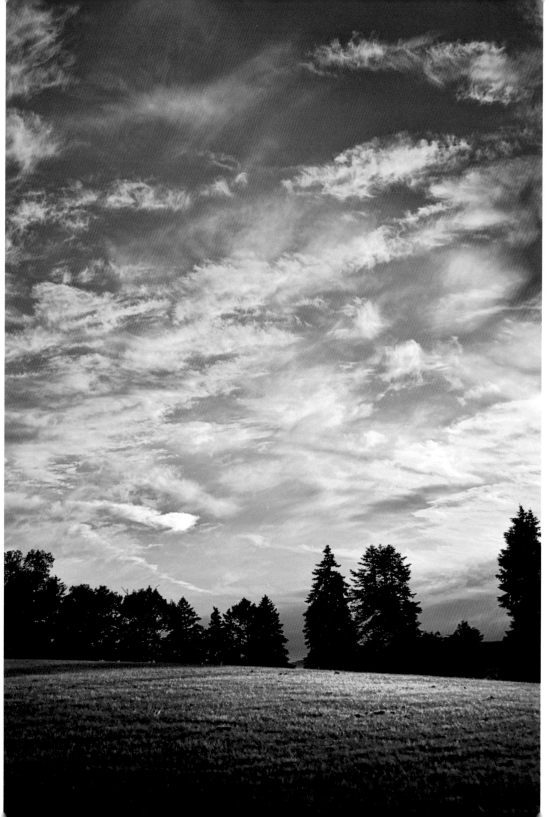

AT SUNSET IN THE PARK: Captured this as the sun was setting. Photo taken: Samuel Lewis Park. 📷 TONY SCHLIES

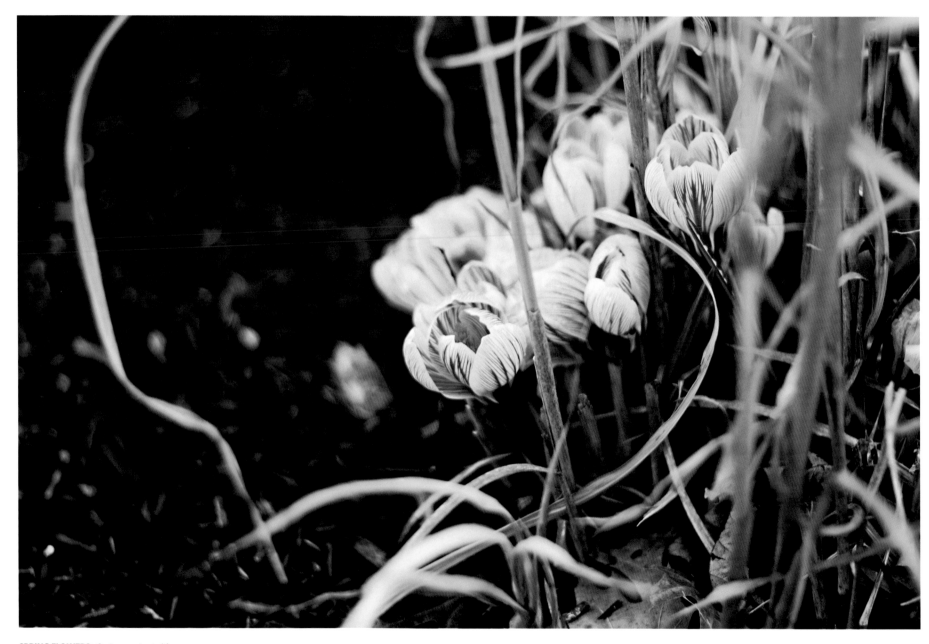

SPRING FLOWERS: Spring coming to life
before our eyes. Photo taken: Etters, PA.
📷 TRACY KAYE

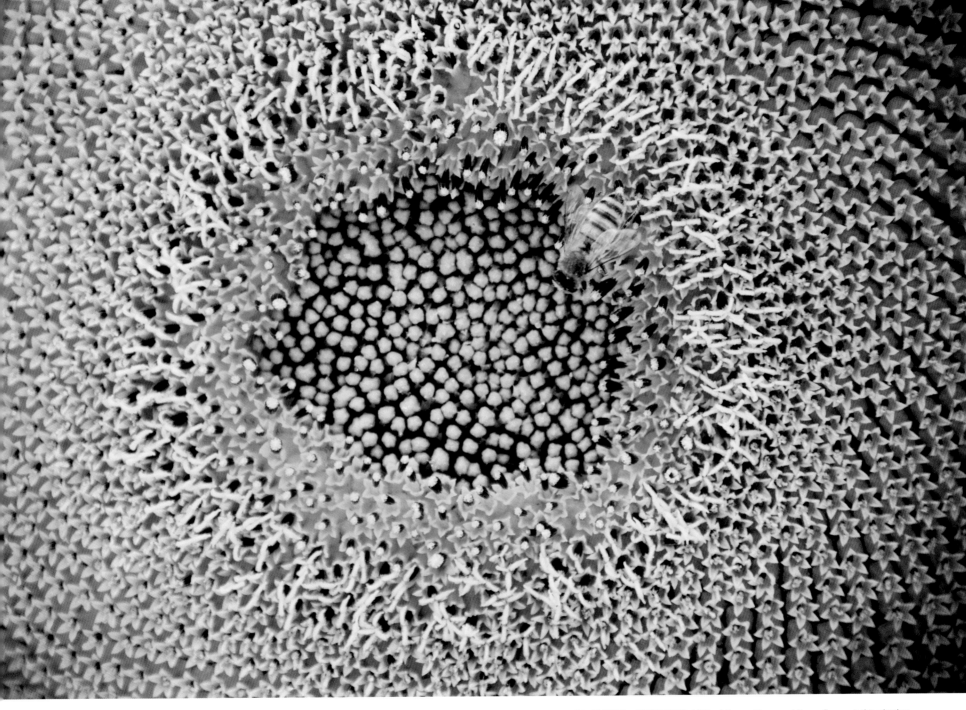

SUN + FLOWER = SUNFLOWER: Without the sun there would be no flower... is this why they call it sunflower? Photo taken: Manchester, PA. 📷 TRINITY WALKER

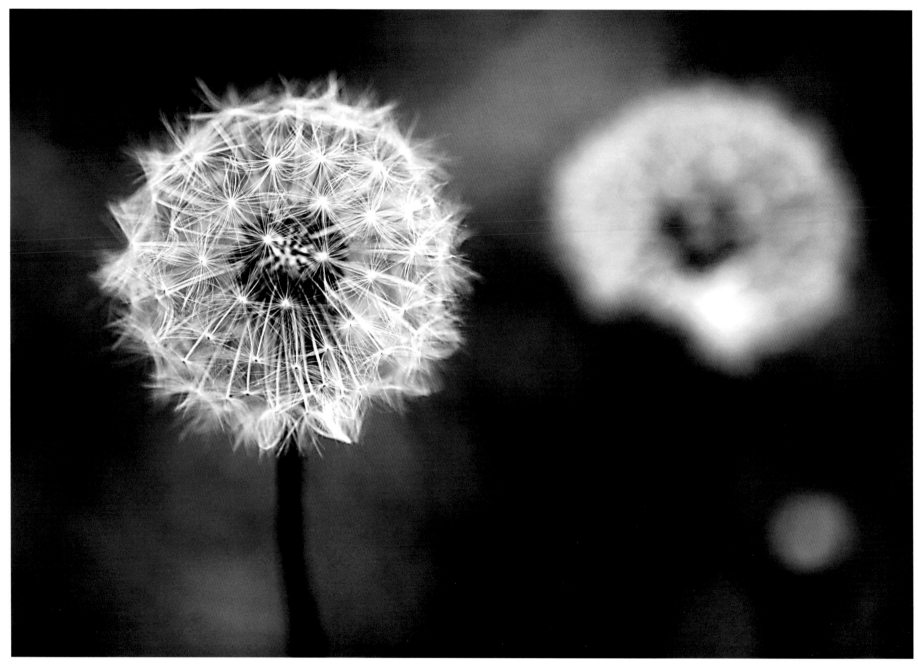

DANDELION'S GAZE II: Two near-perfect dandelions. Photo taken: Red Lion.
📷 JANICE ZIMMER

BABY WREN (*opposite*): A strange and wondrous new world. Photo taken: Spring Grove, PA. 📷 JULIANN LANGEHEINE

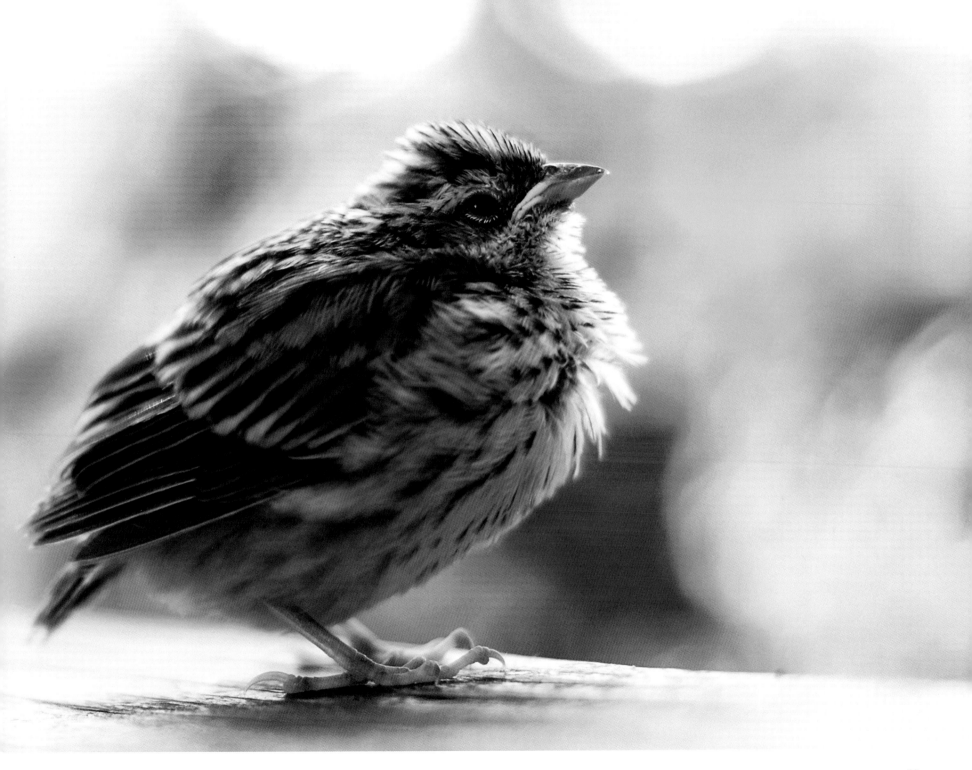

Sports & Recreation

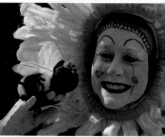
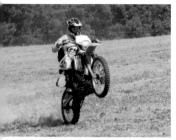
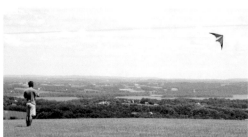
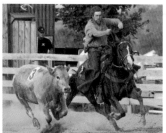
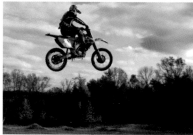
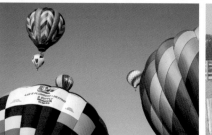
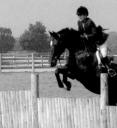
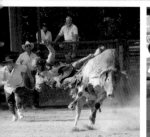
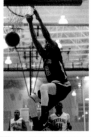
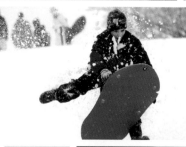
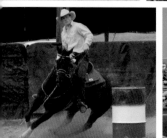

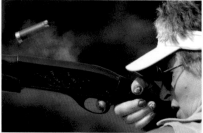
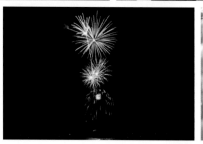
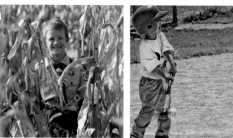
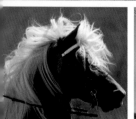
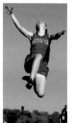
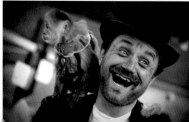
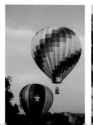
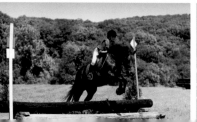

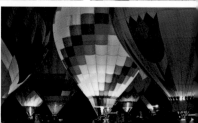

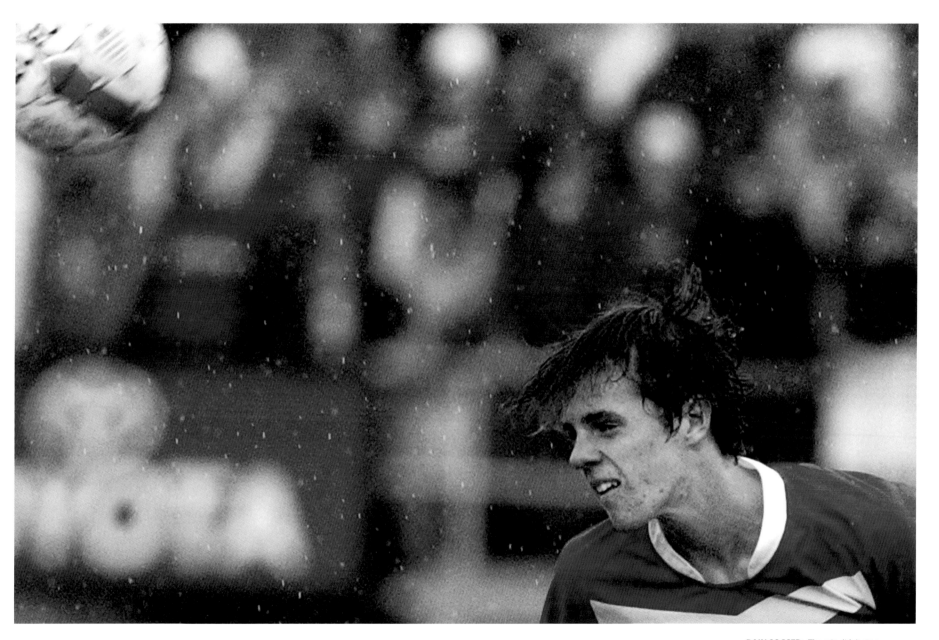

RAIN SOCCER: The rain didn't stop Susquehannock junior defender Nick Amberman from going after the ball in their state title game against Pottsgrove.
📷 JASON PLOTKIN/INYORK.COM

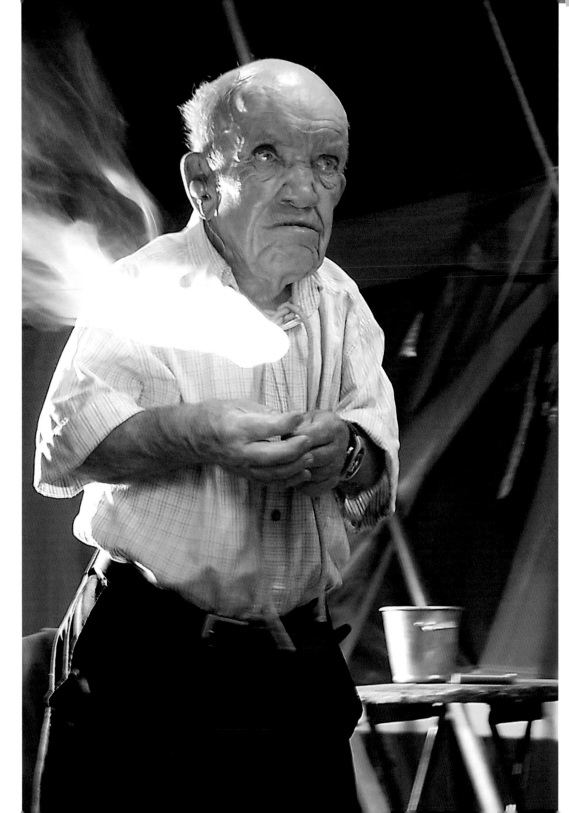

FREAKSHOW FIRE EATER: This man has been eating fire at the York Fair for 35 years or so. Photo taken: The Great York Fair. JULIANN LANGEHEINE

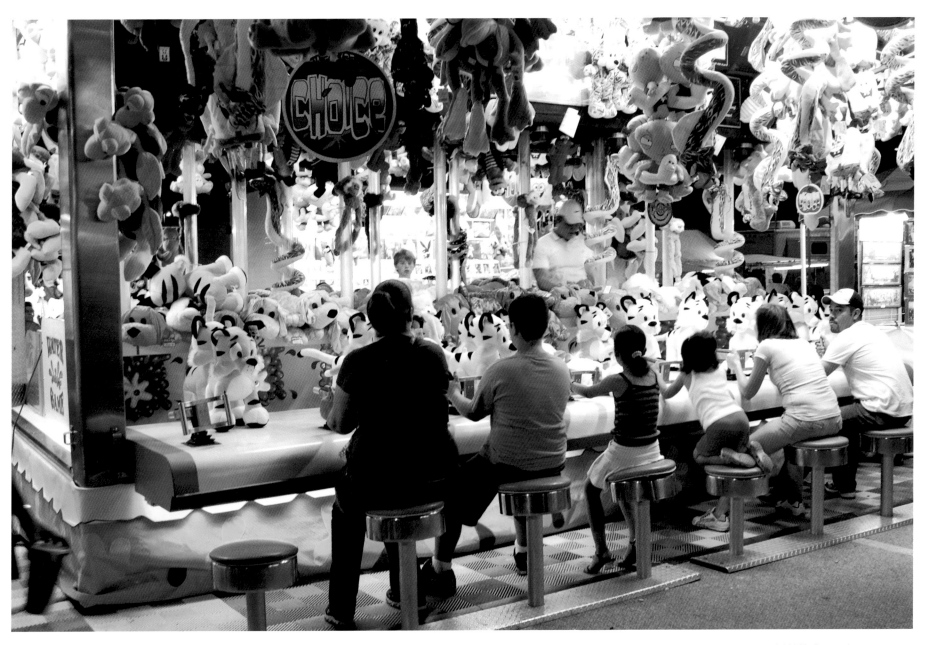

STEP RIGHT UP!: Everyone's a winner at the York Fair. Photo taken: York, PA.
📷 AMY STAUB

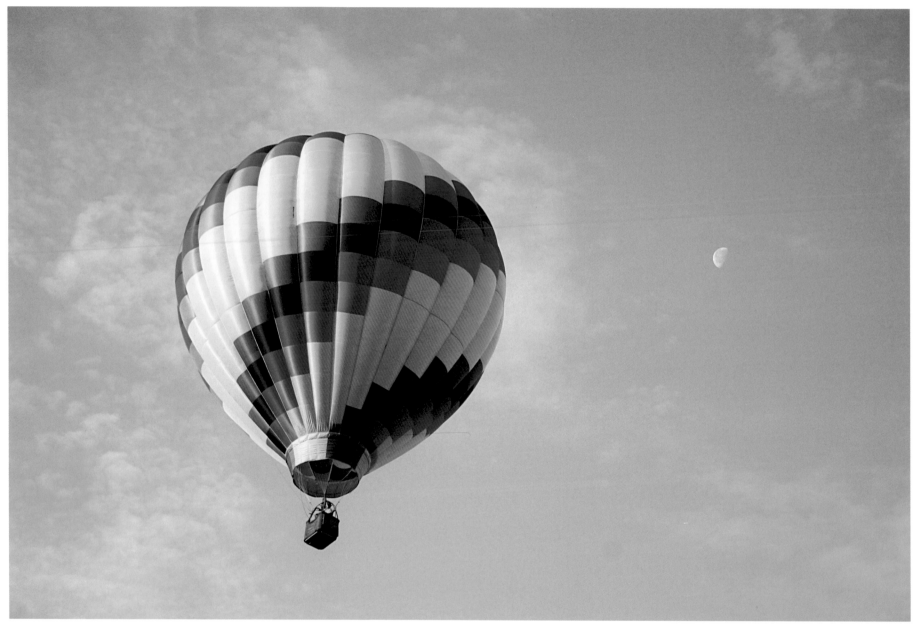

BALLOON & MOON: York Hot Air Balloon Festival. Photo taken: John Rudy County Park. 📷 JANICE ZIMMER

BURN (*opposite left*): Night burn at the York Hot Air Balloon Festival. Photo taken: John Rudy County Park. 📷 JANICE ZIMMER

FLYING KITE (*opposite right*): Can I go higher? Photo taken: Sam Lewis State Park. 📷 STEPHANIE BARSHINGER

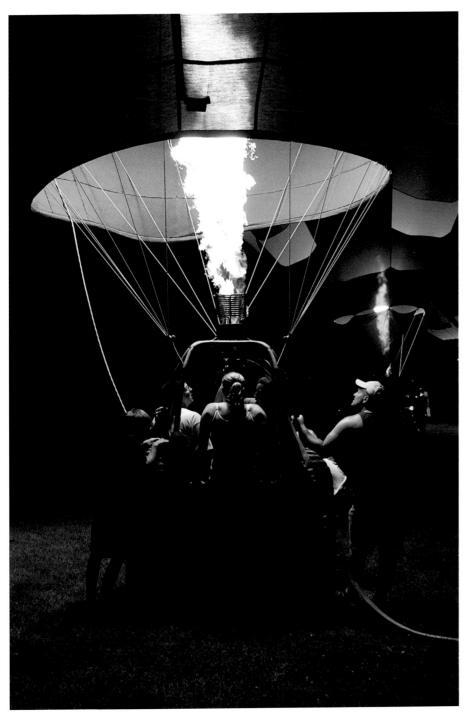

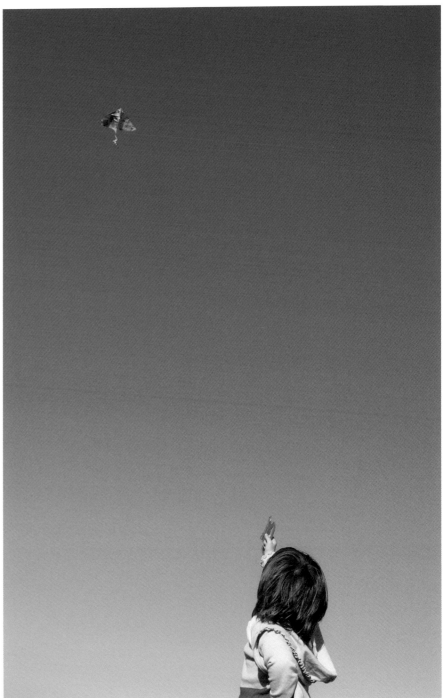

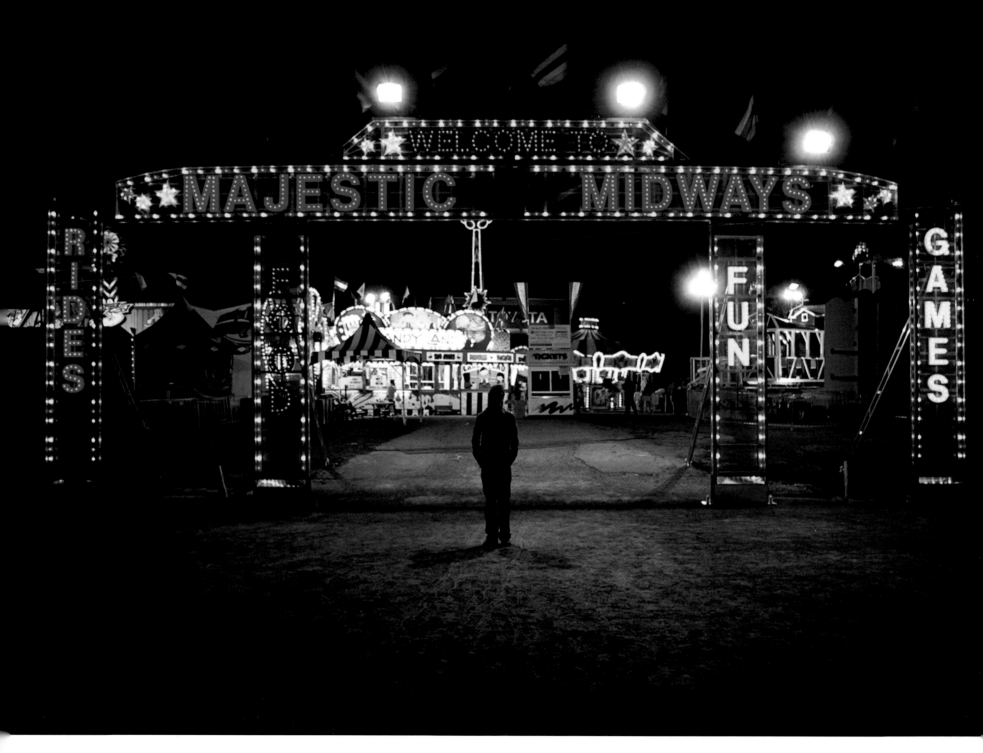

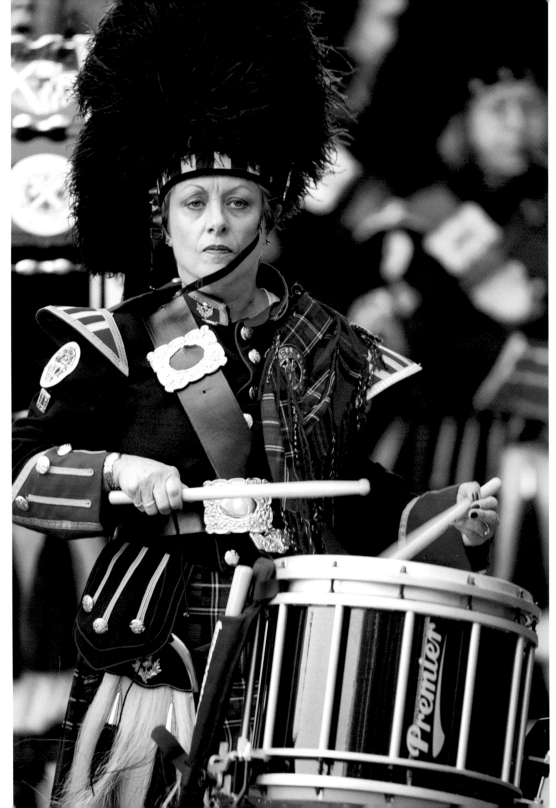

MAJESTIC MIDWAYS (opposite): An impromptu stop at the spring carnival in the York Fairgrounds. Photo taken: York Fairgrounds, York PA. 📷 SETH NENSTIEL

LOCAL PRIDE: Kiltie Band of York drummer plays in a parade. Photo taken: York City. 📷 JEFF HIXON

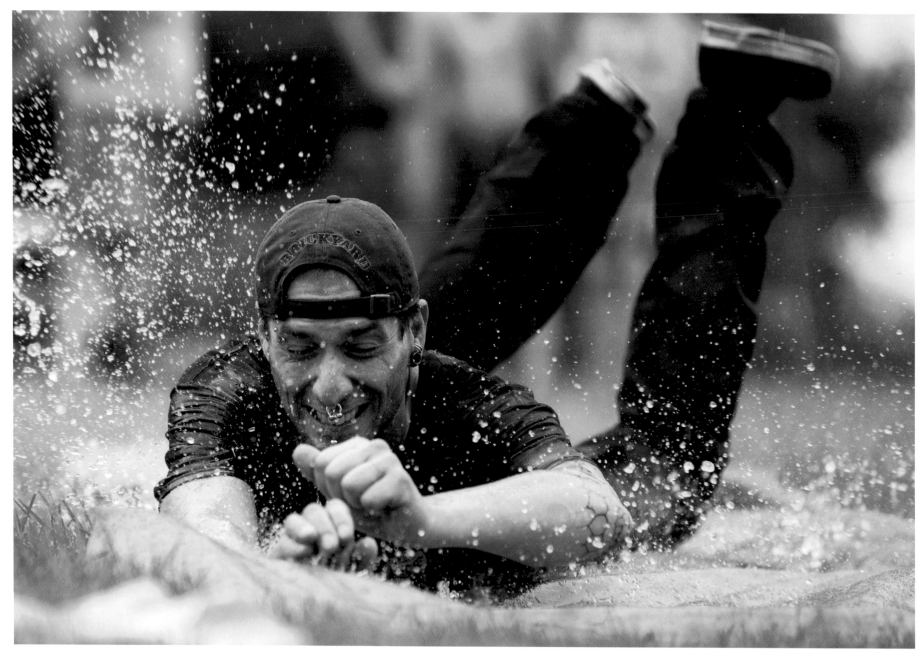

PAV SLIDE: Christopher Pavoncello enjoys a water slide at his family birthday party. Photo taken: York. 📷 JEFF HIXON

BASEBALL *(opposite):* The York Revolution's Frank Castillo throws a pitch during the first inning of a War of the Roses game against the Lancaster Barnstormers at the Sovereign Bank Stadium. 📷 KRISTIN MURPHY/INYORK.COM

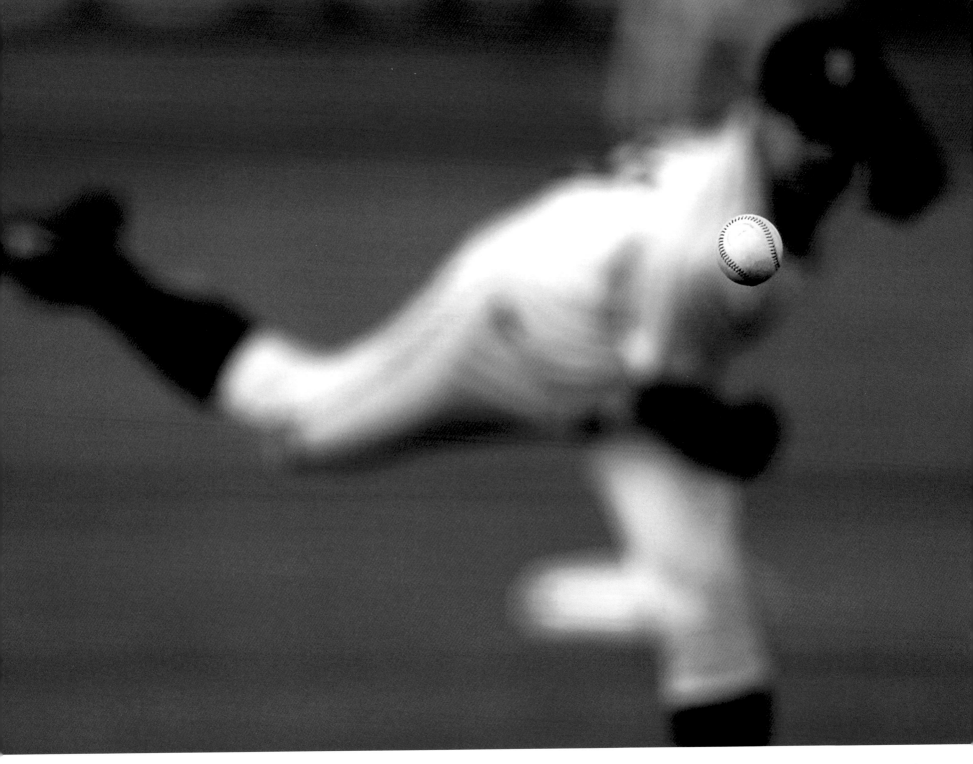

TAKING IT HOME: York Little League player throwing the ball to home base. Look at the expression on his face. He really is playing his heart out. Photo taken: York, PA. 📷 DANIEL SOVERAL

OLD SOFTBALL *(opposite):* An old softball I had from when we played as kids. A macro photo showing the lines and textures. Photo taken: My home. 📷 DEB PACKARD

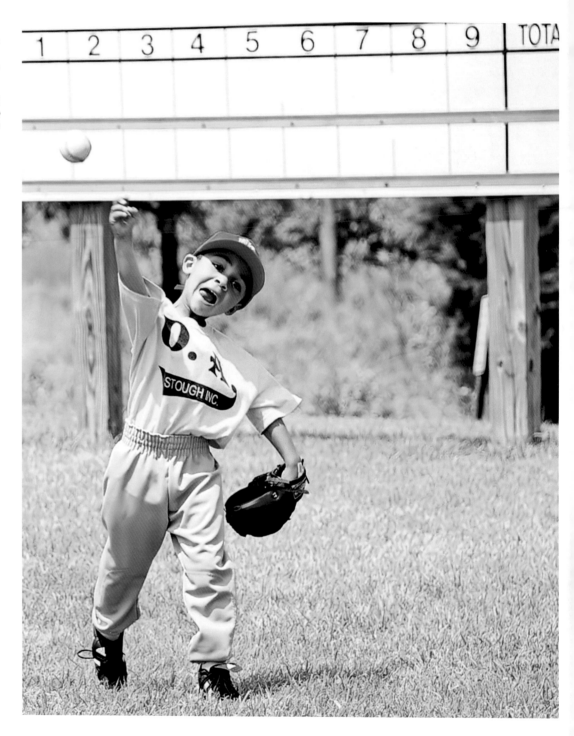

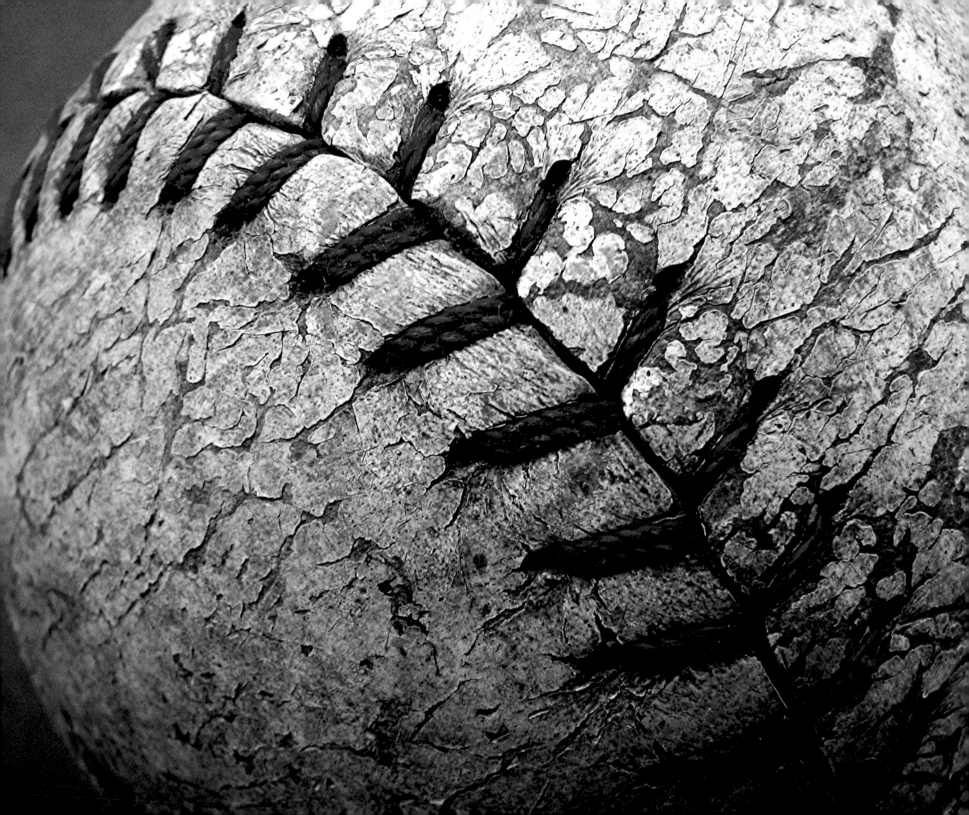

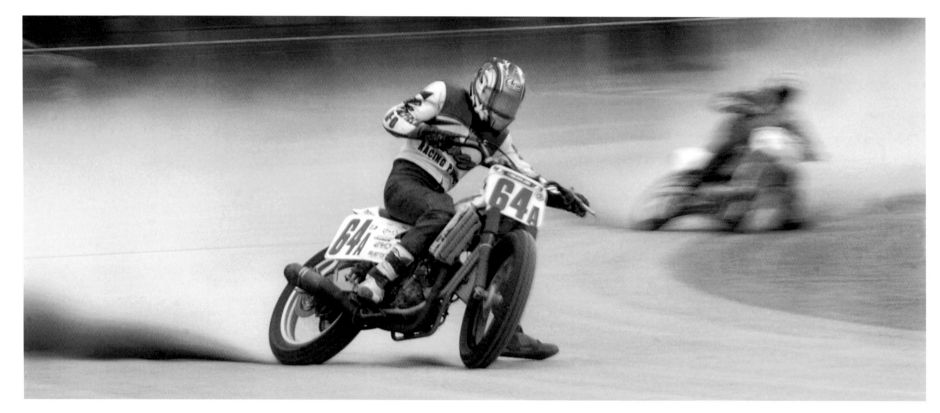

DIRT TRACK: Professional motorcycle racers Evan Baer, left, and Tom McCrane duel around a turn at the York Expo Center's half-mile pea gravel track. 📷 BIL BOWDEN/INYORK.COM

HILLCLIMB *(opposite)*: Paul Kops leaves a cloud of dust behind as he races to the top of a 300 ft. high hill during the White Rose Motorcycle Club's 800cc hillclimb in Codorus Township. 📷 KRISTIN MURPHY/INYORK.COM

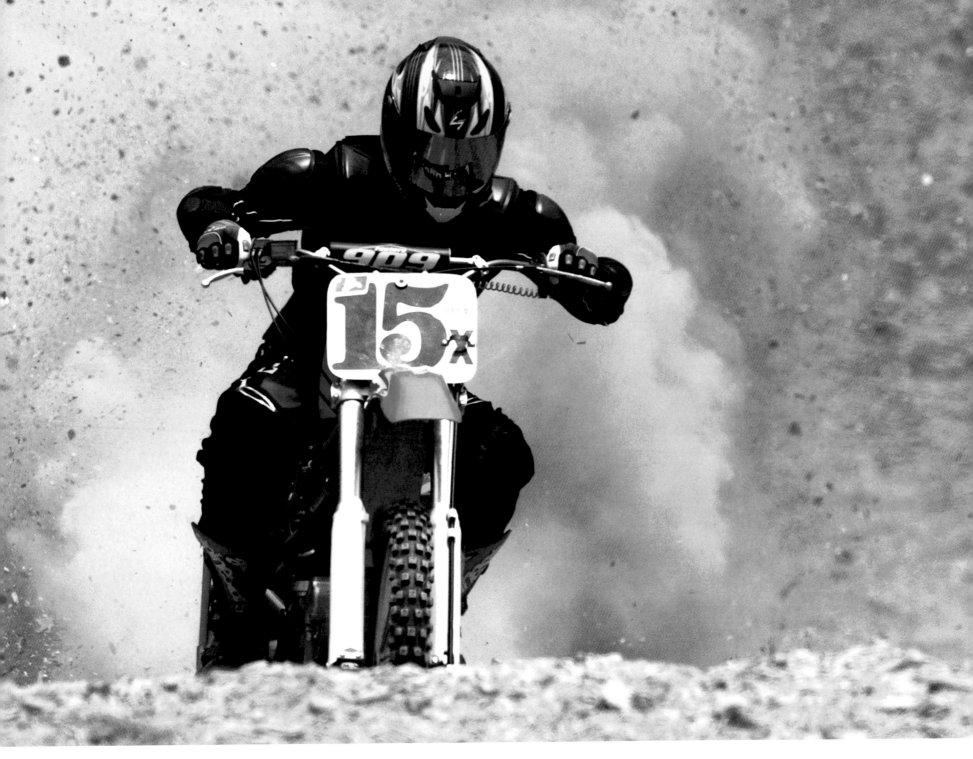

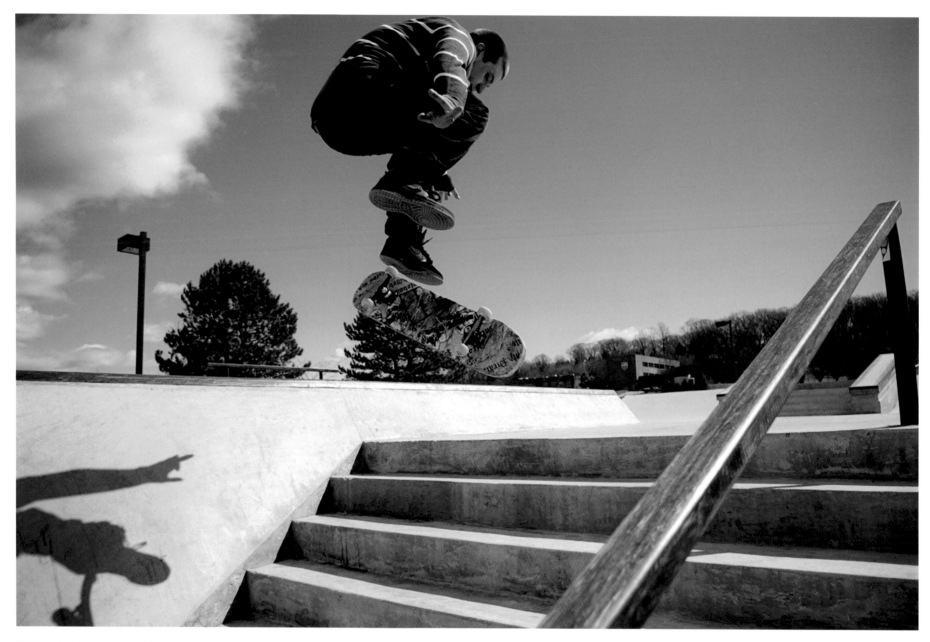

FLIP: Nothing beats a day at the skate park jumping stairs. Photo taken: Reid Menzer Memorial Skate Park, York PA. 📷 SETH NENSTIEL

⭐ **FISHING** *(opposite):* Early-morning fishing at Gifford Pinchot State Park taken from the north side of the lake as the sun was rising. Photo taken: Gifford Pinchot State Park, Lewisberry, PA. 📷 JANICE BENDER

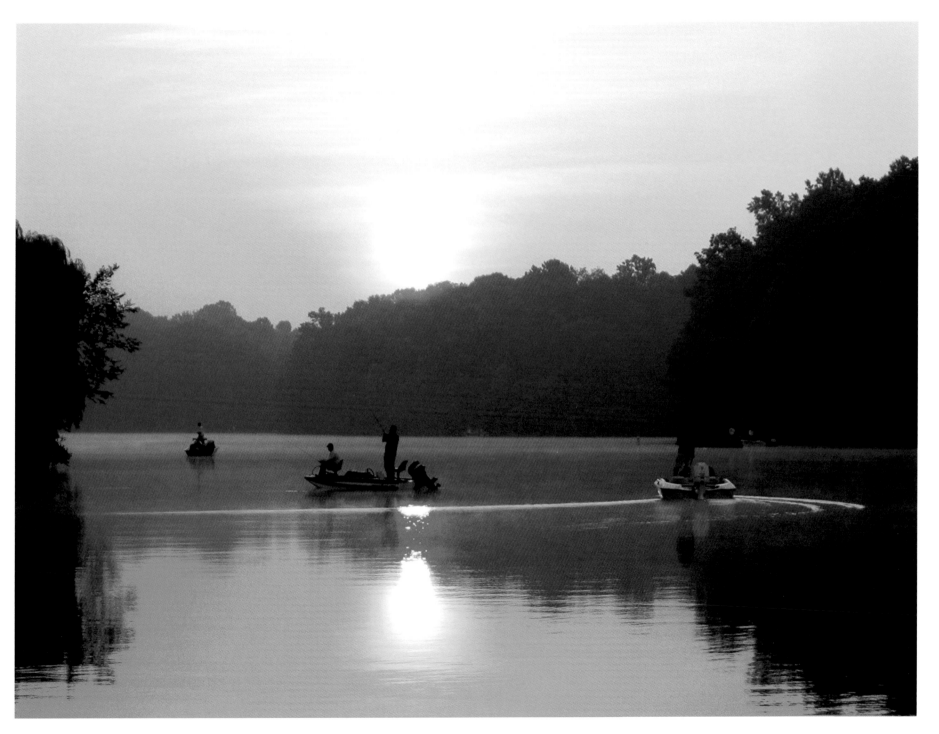

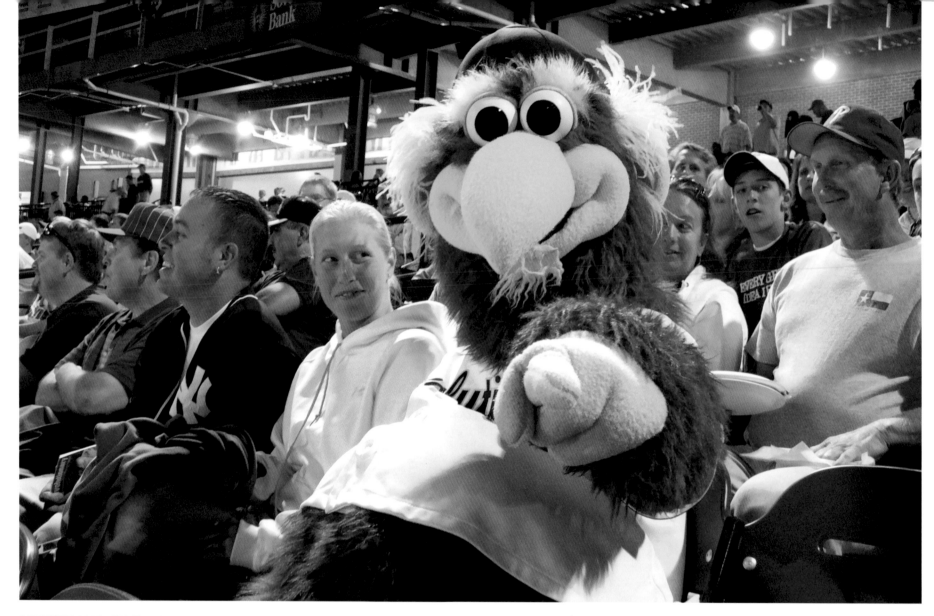

DOWNTOWN WANTS YOU: The York Revolutions' mascot, DownTown, at the first game played by the Revolutions in their new stadium. Photo taken: Sovereign Bank Stadium
📷 PHILIP WOODS

★ **WHEN DOGS FLY** *(opposite):* Dock dogs competition at the Summer Blast event held on the banks of the beautiful 1,275 acre Lake Marburg with 26 miles of shoreline, surrounded by the 3,329 acre Codorus State Park located in southwest York County. Lake Marburg's waters cover the former small community of Marburg – its namesake. An impoundment dam constructed on the Codorus Creek forms the lake. A joint project between the Commonwealth of Pennsylvania and the P. H. Glatfelter Paper Company of Spring Grove. It was the first collaboration of its kind between the state and a private industry and provides a top shelf recreation area for the public and a source of water for both "Glatfelter's" and the town of Spring Grove. The State park was established as a result of the Project 70 land acquisition program in 1965 and 1966. The project 500 bond program and the federal government's land and water conservation fund financed construction of the park's facilities and infrastructure. It was dedicated for use on May 9, 1970. I still refer to this area as "Project 70" Photo taken: Codorus State Park. 📷 ALAN HORN

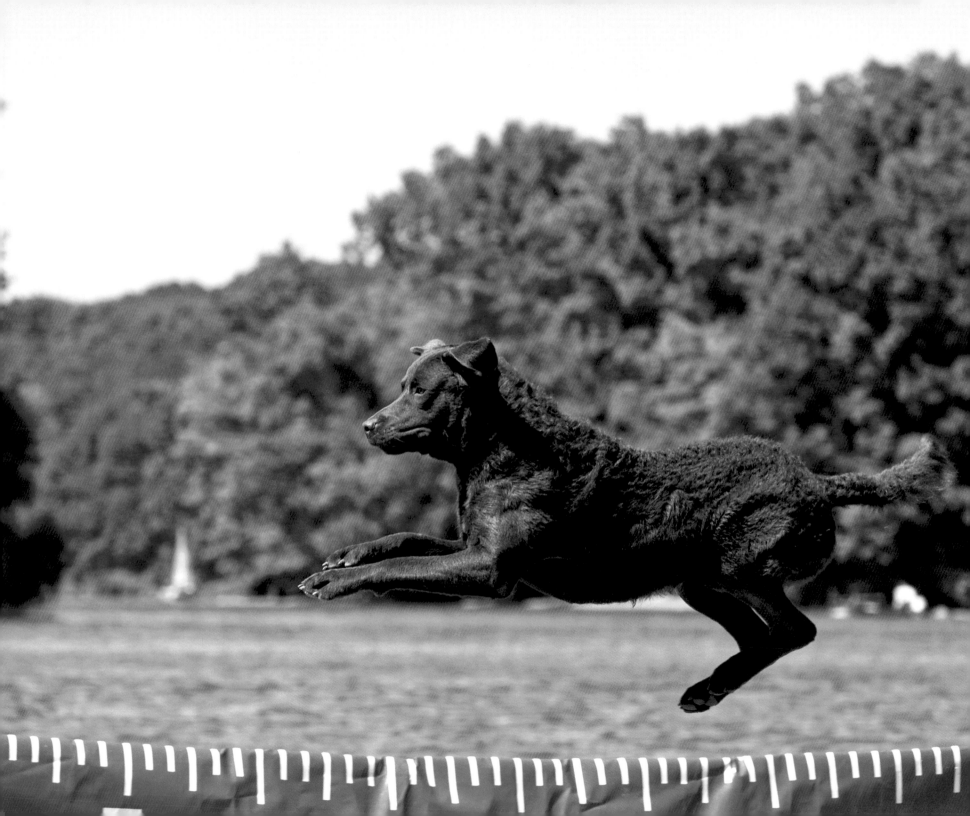

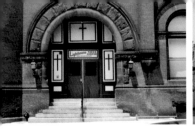
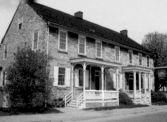
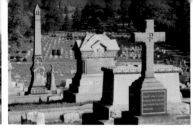
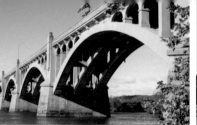
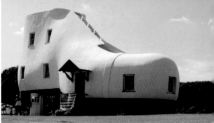

Local Flair

This is a special chapter. What makes it special? The photos in this chapter were flagged by users as being local icons. We pulled them from the other eight chapters to set them apart and to create a fun chapter that's all about iconically local stuff. So, here's the best of those flagged as a local icon.

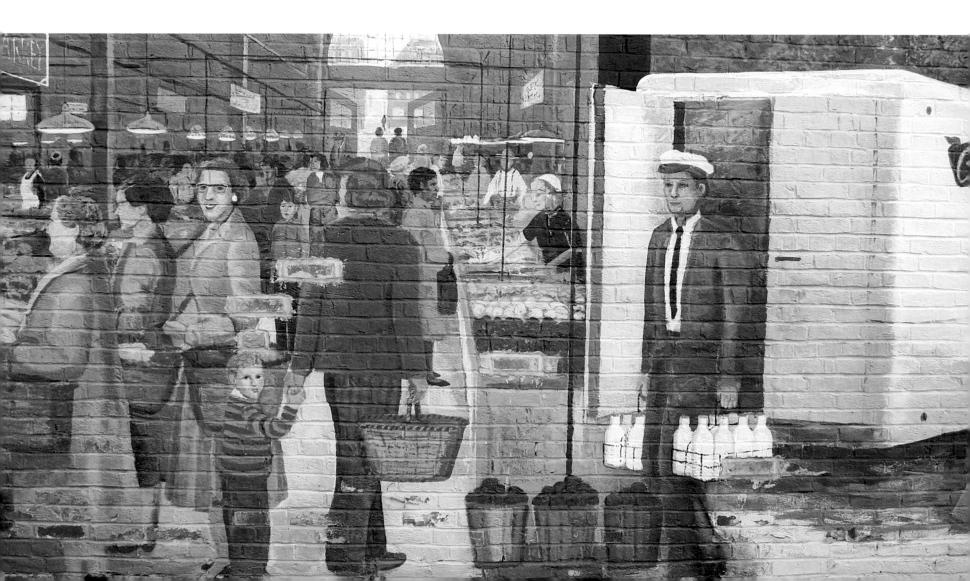

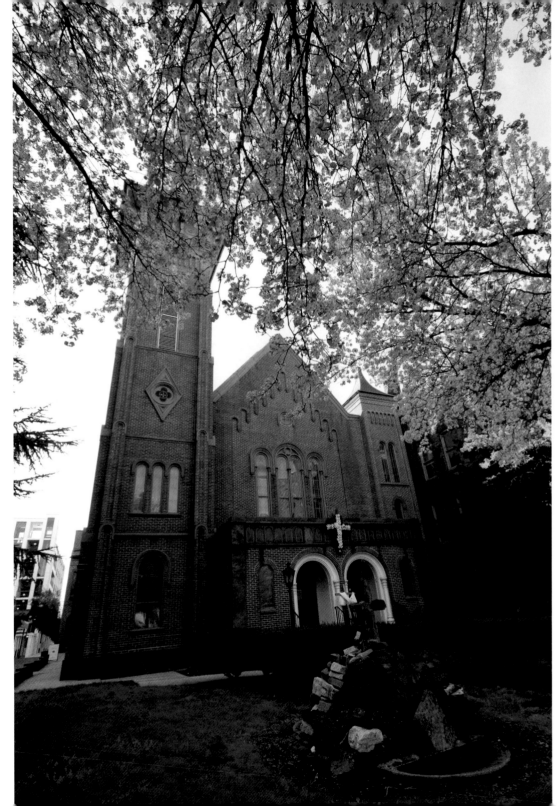

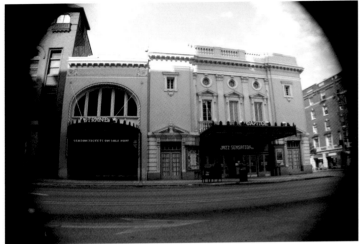

THE STRAND (*above*): The Strand in a different light. Photo taken: York, PA. 📷 JUTTA STALLMAN

TRINITY UCC (*left*): Trinity United Church of Christ at Easter time. Photo taken: West Market St., York. 📷 DEB PACKARD

CENTRAL MARKET MURAL (*opposite*): Mural on the side of the building opposite the White Rose Bar & Grill. Photo taken: Beaver Street. 📷 JOE WAMSLEY

CENTRAL MARKET (*following top left*): A view of Central Market from the rafters. Photo taken: 34 W. Philadelphia Street. 📷 DIANNE BOWDERS

HANOVER JUNCTION (*following bottom left*): Hanover Junction Station at springtime. Photo taken: Heritage Rail Trail County Park. 📷 DWIGHT NADIG

FROM THE GROVES (*following middle*): Old fruit store on Roosevelt Avenue. Photo taken: York, PA. 📷 DANIEL SOVERAL

CENTER SQUARE (*following right*): Beautiful day on Continental Square. Photo taken: George and Market streets. 📷 JOE WAMSLEY

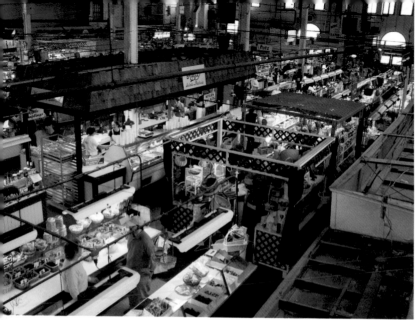

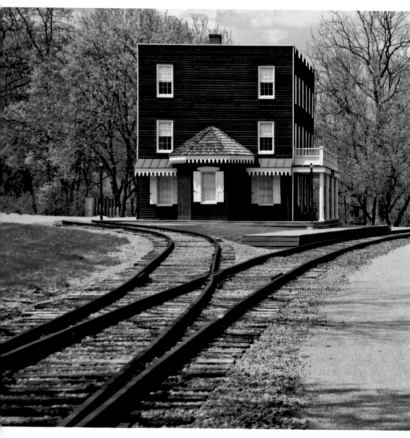

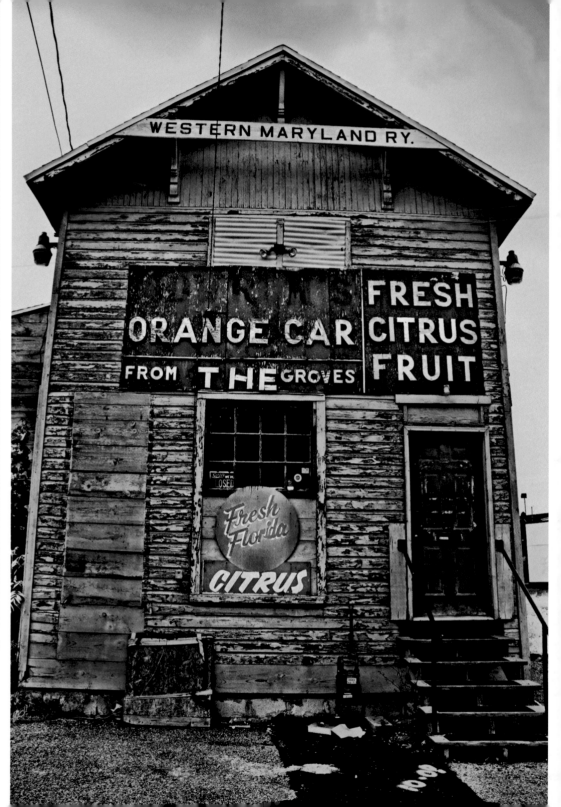

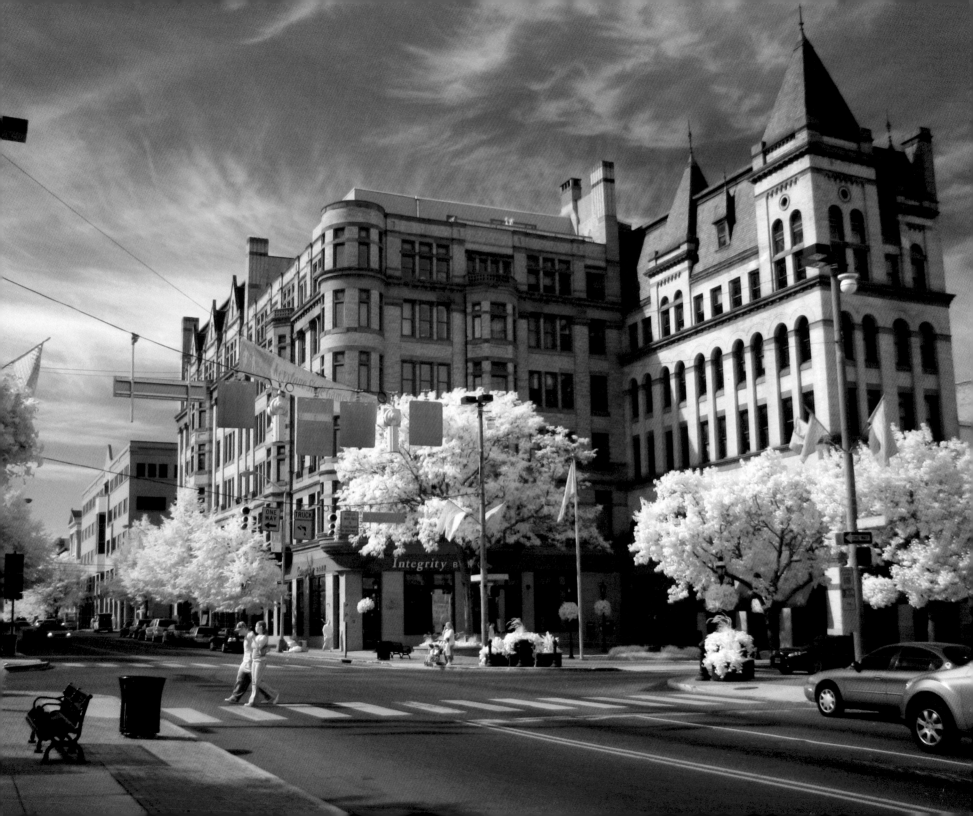

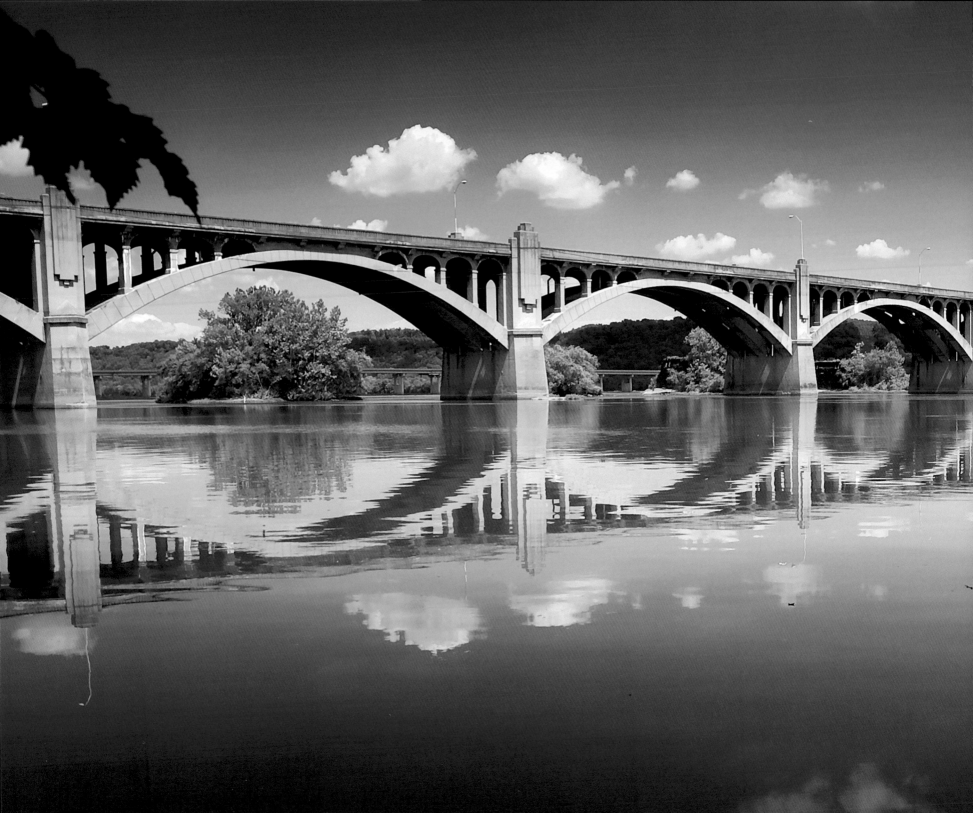

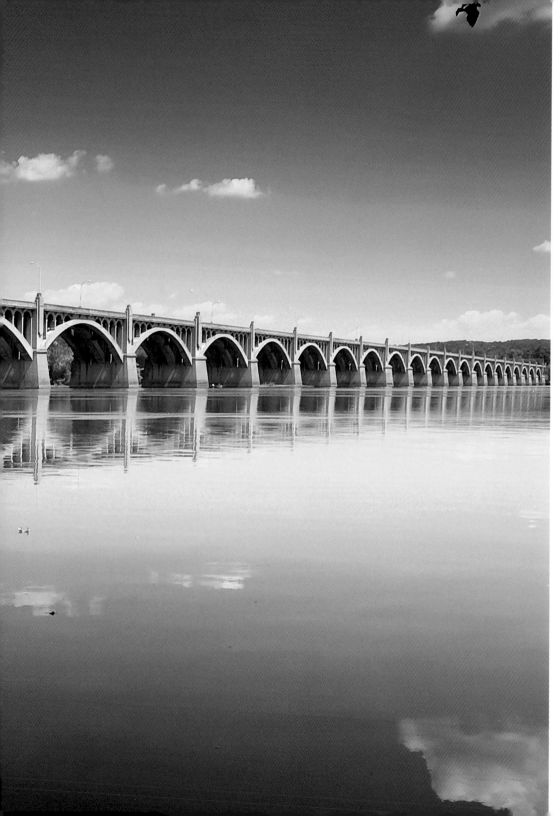

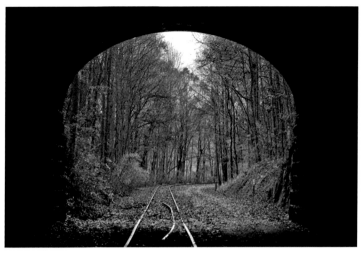

INSIDE THE HOWARD TUNNEL *(above):* Howard tunnel section of the 21-mile-long Heritage Rail Trail County Park. The trail runs from the center of York city to the Maryland State line and encompasses 176 acres. Photo taken: Heritage Rail Trail County Park. 📷 ALAN HORN

BRIDGE REFLECTION. *(left):* Veterans Memorial Bridge on a calm summer day. Photo taken: Wrightsville. 📷 DWIGHT NADIG

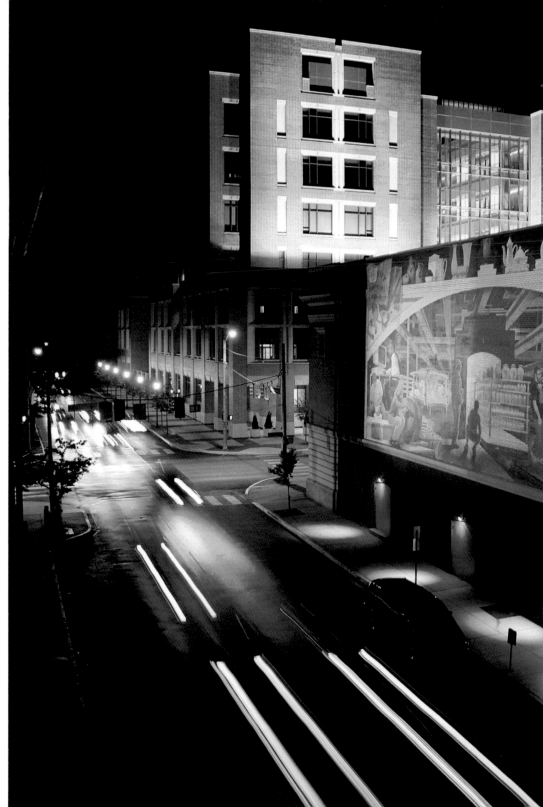

NEITHER SNOW NOR RAIN NOR HEAT NOR GLOOM *(above):* United States Post Office in downtown York. 📷 JAMIE BOVENDER

PHILA. ST. AT NIGHT *(right):* Philadelphia and George streets from a parking garage. 📷 JOE WAMSLEY

PARACHUTE *(opposite):* Regents Glen Country Club, taken from their gardens looking up to the mansion. Photo taken: York, PA. 📷 FRANK BELL

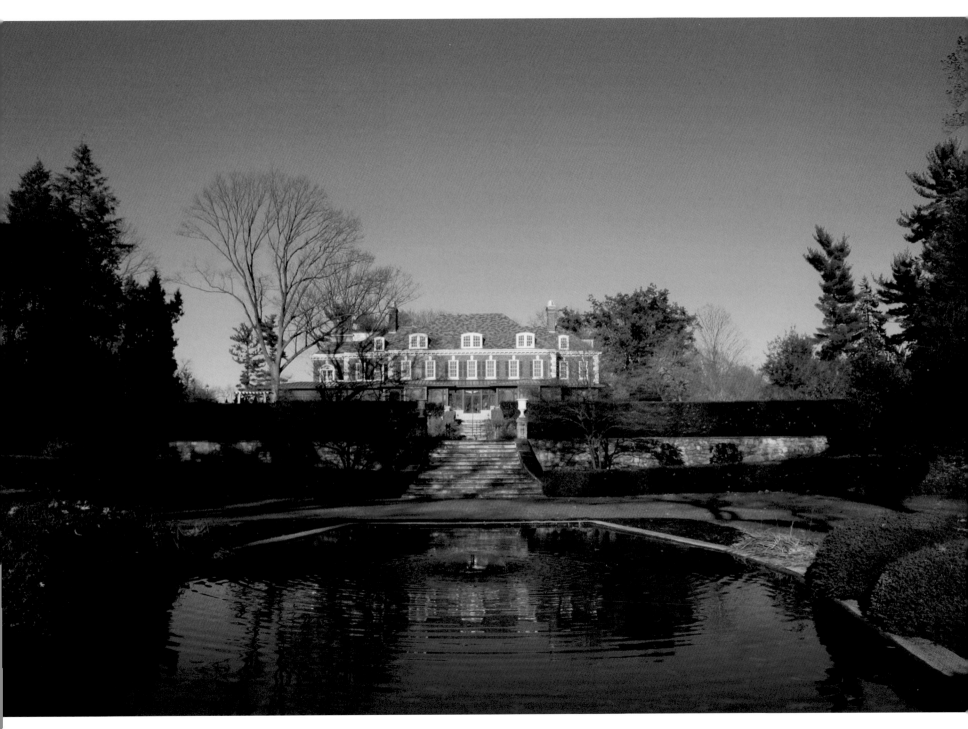

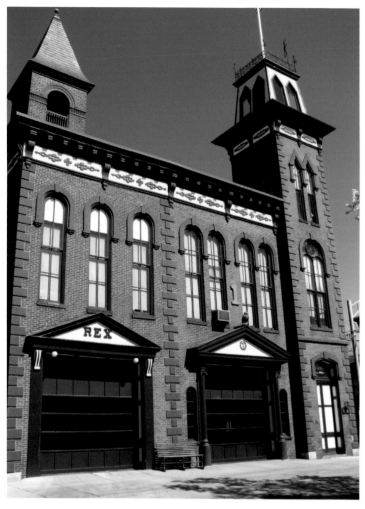

REX FIREHOUSE *(above):* Rex Firehouse. I think they are the only one left in the city to use the pole to slide down when a call comes in since they sleep upstairs. Photo taken: downtown York. 📷 MELANIE WALLACE

HERE IS THE STEEPLE *(right):* The Christ Lutheran Church steeple. Photo taken: downtown York. 📷 AUDRA JON HOOVER

EMANUEL CEMETARY *(opposite):* Emanuel Cemetery is located out past Rosstown, at the corner of Pinetown Rd. and Rosstown Rd. 📷 JASON FEGELY

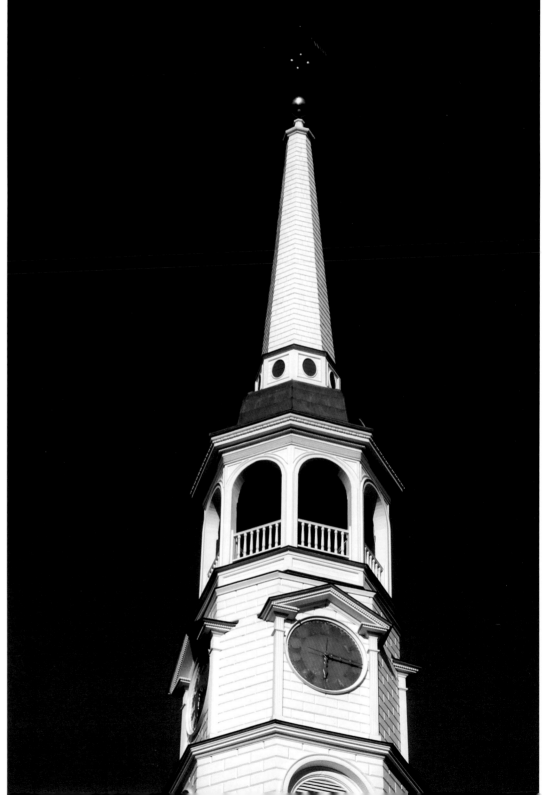

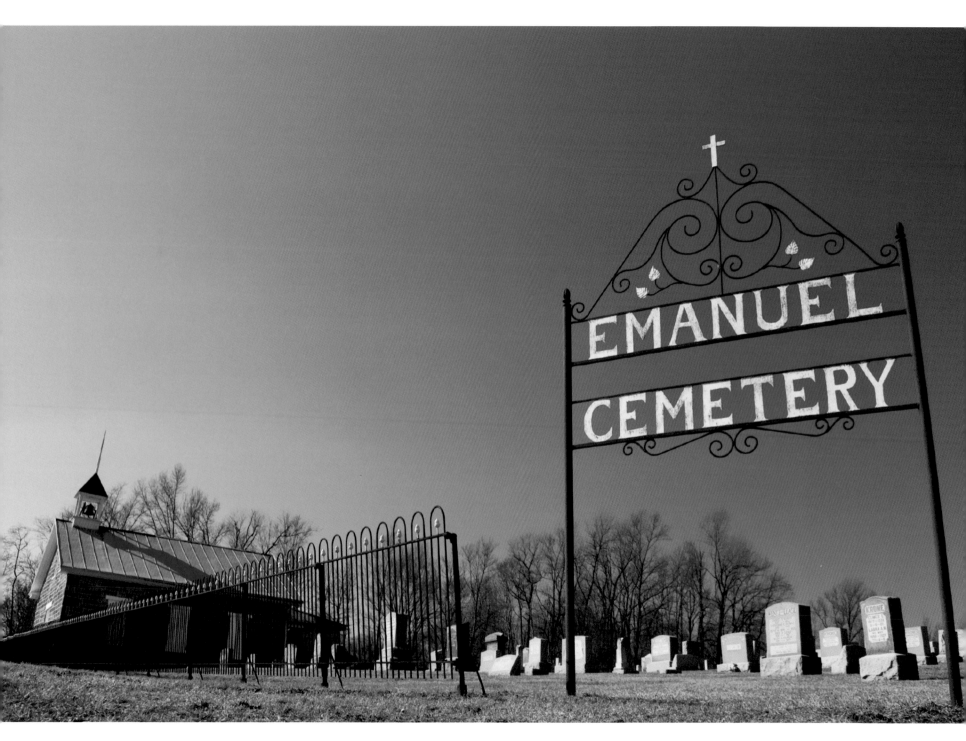

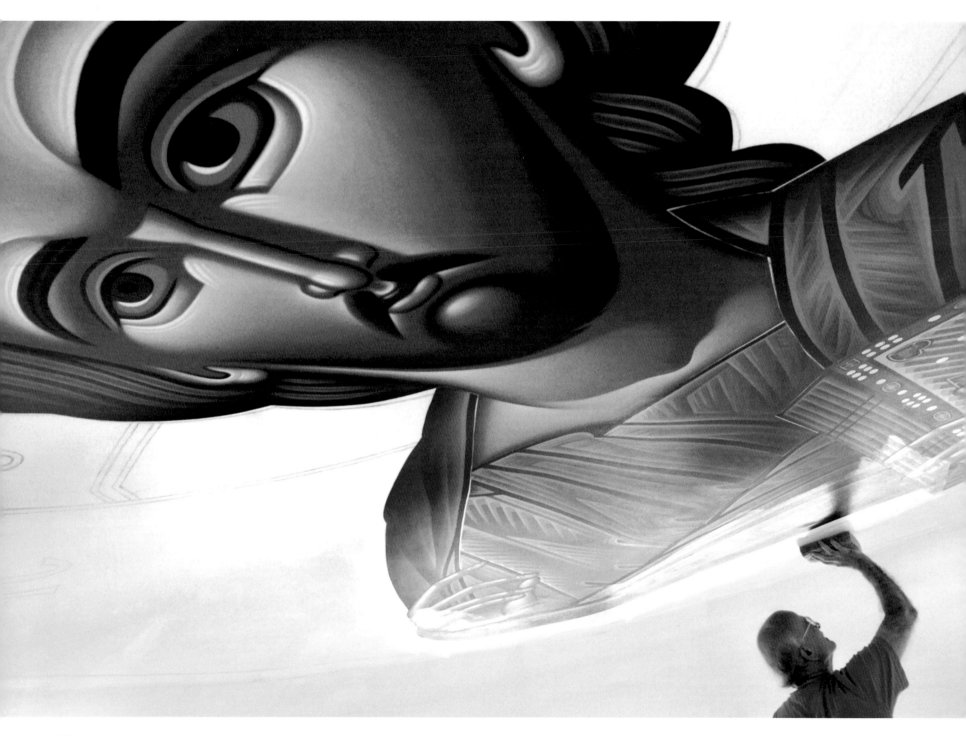

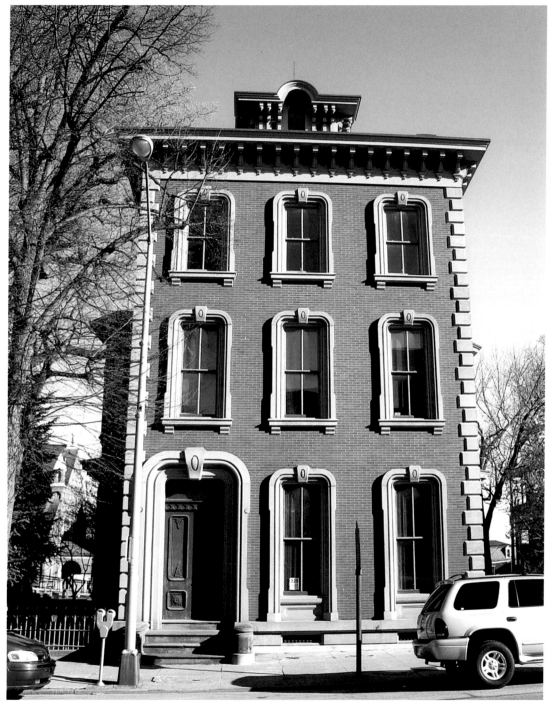

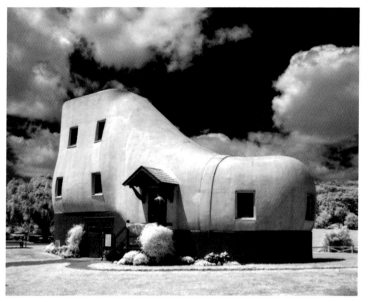

CHURCH ICONS *(opposite):* Kneeling on scaffolding, iconographer Elias Katsaros cleans up paste around a Byzantine-style icon of Jesus as Pantocrator, or 'Ruler of All,' representing Jesus at the Second Coming. Katsaros, 62, of Huntsville, Ala., painted the icon on heavy canvas and cut it into 18 pieces to mount on the 35-foot-high dome of St. John Chrysostom Antiochian Orthodox Church in Springettsbury Township. 📷 JASON PLOTKIN/INYORK.COM

THE SHOE HOUSE *(above):* Digital infrared shot of the Shoe House. Photo taken: Shoe House Rd. 📷 JOE WAMSLEY

THE YORK HOUSE *(left):* A front view of the beautiful Victorian Italianate York House or Billmeyer House, built by Charles Billmeyer in 1863. The house is part of the First Presbyterian Church complex. The home now stands as a beautiful testament to preservation. Photo taken: East Market Street. 📷 DIANNE BOWDERS

Capture York was made possible by local photographers who were willing to share their talents with the rest of us. Here's a list of everyone you'll find in these pages and on the DVD. If you know any of these folks, give them a ring and say thanks for the great book!

(Photographers with Web sites in following list.)

DOLORES ADAMS	JENNIFER CARTER	DAVID GINTER
DARLENE AIRHART	LISA CATHERMAN	PHILIP GIVEN
ANDREA ALBERT	KEN COOPER	CHRISTOPHER GLASS
LENNY BAKER	CRAIG COPAS	MARG GOTWALD
IAN BARNHART	LEADA DIETZ	JERRI GUTTMAN
STEPHANIE BARSHINGER	KIMBERLEY DOWNS	DORCAS HAVERSTICK
JARED BEAN	VICKIE DUNLAP	LYLA HESS
AMANDA BECKER	RUSTY ENTERLINE	ALISSA HESS
JANICE BENDER	SCOTT ESHELMAN	SONJA HICKS
CHRISTI BERNLOHR	GEORGETTE EVELAND-ALOSA	SHARI HILBERT
ANN MARIE BOLEN	GINI FEATHERSTONE	JEFF HIXON
KEN BORROR	MOLLY FORTENBAUGH	AARON HOCK
JAMIE BOVENDER	ALESIA FRITTS	TAMMY HOUGENTOGLER
BIL BOWDEN	AUDRA FULGINITI	RICHARD HUNSINGER
DIANNE BOWDERS	DAPHNE FULLER	MIKE INKROTE
STEPHANIE BOYER	LINDA GALLAGHER	LORI JACOBS
SUZETTE BRUMBAUGH	ABBY GIBB	MICHELE JOHNSON
RICH BULGARELLI	ELLEN GIBB	TRACY KAYE

BONITA KERN	AMELIA PHARO-FRANK	
PAUL KUEHNEL	JASON PLOTKIN	PAUL WALKER
JOSEPH LEECE	KAREN POTTS	JOE WAMSLEY
GAYLORD LENTZ	CHRIS POTTS	JACKIE WASBERS
VAUGHNLEA LEONARD	CASEY PRATHER	HILARY WHITE
LAUREN LLOYD	DON PRESSEL	BRIAN WILLIAMS
PAT LONG	ELAINE PRIEST	MARY WILLIAMS
JOANNA LOPEZ	STACY ROBINSON	BREANNA WINTERS
ALISON LUSK	KARIN ROTH	MELISSA WITMER
LESLIE MALLON	MARCY ROYCE	PHILIP WOODS
RHONDA MARKEL	ALETTA SALTER	KRISTA YOHE
NANCY MARLOW	MICHELLE SANDERS	TIFFANY YOUNG
SUSAN MASENHEIMER	TONY SCHLIES	GERALD YOUNG
JOANNE MAY	DOUGLAS SCHRIVER	JOSHUA YURCHE
SARA MCKILLOP	REBECCA SHAFFER	SARA ZIMMERMAN
BOB MILLER	KYLE SIMON	HEATHER ADAMS
FRANK MORITZ	STEVE SMITH	JEWEL ALLOWAY
KRISTIN MURPHY	JUTTA STALLMAN	ANTHONY BEARD
CAMERON MURRAY	BECKY STEPHENS	BLAIR BRUMBAUGH
SUSAN NESS	ROXANNA STRINE	BILL FUHRMAN
SHEENA NEWSON	SAMANTHA SUE	BOB GOTWALT
DONALD NICKOL	REBEKAH SWEENEY	MICHAEL MARSTON
JILL OLES	SHANNON SYLTE	CHRISTINA MUELLER
DEB PACKARD	PATRICIA TELLER	CHRIS SEMPER
KATE PENN	BOB THOMAS	LAURA SLENKER
HEIDI PERO	STACEY TITEMORE	CHARLENE SMELGUS
GREGG PETERSON	TOM TROOP	MELANIE WALLACE

If you like what you see in the book and on the companion DVD, be sure to check out these photographers' Web sites. A few even sell prints so you may be able to snag your favorite photos from the project to hang on your wall.

LISA AMSPACHER	CINDY GILBERT	JEFFREY A. MOORE	
campinglisa-life.blogspot.com/	harvestviewstables.com	countryroadphotography.com	
FRANK BELL	AUDRA JON HOOVER	DWIGHT NADIG	
flickr.com/photos/theysayjump/	ajhoover.com	photoshopuser.com/members/portfolios/view/gallery/1229662	
JENNIFER BORROR	ALAN HORN	SETH NENSTIEL	
jenscreativedesigns.com	cavewolf.com	pyrosarco.com	
INK BYERS	CHRISTINE HSIEH	JUDITH ORCUTT	LEANNE SULLIVAN
inkbyers.zenfolio.com	christinehsiehphotography.com	quilligraphy.com	scuba.com/me/dive-time
TEANNA BYERTS	SHAWN HUBER	JO OTT	LENNY TATARA
geocities.com/swordwhale	shawnhuberphoto.com	exit3583photo.com	groups.yahoo.com/group/americanartistclub/
BRIAN COOPER	WADE KELLER	DARIN POTTS	PATRICK THOMAS
coopshome.us	shotinyork.com	dsp-designs.com	flickr.com/photos/patrickhenrythomas
DIANA CRAMER	JULIANN LANGEHEINE	MEGAN SCHROLL	JENNIFER TITEMORE
cramerphotography.com	flickr.com/photos/skyblue_pink/	flickr.com/photos/liveabundantly_4Him/	cedarhillart.com
BRANDON DIEHL	MELINDA LEPPO	BILL SEELEY	NICHOLAS A. TONELLI
google.com/profiles/popsmit76	myspace.com/babydoll31804	profile.myspace.com/mercyrain	flickr.com/photos/nicholas_t/
TERRY DIETRICH	KATHLEEN MARKEY-LUDWICK	CHRIS SHANE	BRIA TOPPER
myspace.com/peaveydude	datawareinc.com	datawareinc.com	blog.hisdeeplove.com
JASON FEGELY	SCOTT MINGUS	HEATHER SHEARER	RYAN VANDENBERG
flickr.com/photos/yorkjason/	scottmingus.com	myspace.com/headypeanut	flickr.com/photos/veender/
		BERNARD SIAO	TRINITY WALKER
		flickr.com/photos/berniesiao	summerhousephoto.com/
		DANIEL SOVERAL	JANICE ZIMMER
		flickr.com/photos/28579630@N07/	flickr.com/photos/autumncat/
		AMY STAUB	
		als-imagery.smugmug.com	

Chapter Introduction Photographers

The many photographers listed below helped shape the introduction page of each chapter. Many thanks to these fine folks (listed in order of appearance from left to right, top to bottom):

Friendly Faces: Alan Horn, Alissa Hess, Audra Jon Hoover, Bil Bowden, Christine Hsieh, Ink Byers, Sara Zimmerman, Bil Bowden, Jason Plotkin, Jason Plotkin, Jeff Hixon, Jeff Hixon, Jeff Hixon, Patrick Thomas, Jason Fegely, Gregg Peterson, Jeffrey A. Moore, Kate Penn, Krista Yohe, Lyla Hess, Linda Gallagher, Linda Gallagher, Linda Gallagher, Kate Penn, Sara Zimmerman, Jeff Hixon, Juliann Langeheine, Tracy Kaye, Alan Horn, Jason Fegely, Jeffrey A. Moore

Schools & Institutions: Dianne Bowders, Dianne Bowders, Dianne Bowders, Janice Zimmer, Dianne Bowders, Susan Masenheimer, Audra Jon Hoover, Jamie Bovender, Janice Zimmer, Frank Bell, Jason Fegely, Dianne Bowders, Dianne Bowders, Paul Kuehnel, Dianne Bowders, Jason Plotkin, Jeff Hixon, Deb Packard, Bil Bowden, Dianne Bowders, Joe Wamsley, Dianne Bowders, Janice Zimmer, Dianne Bowders, Frank Bell, Janice Bender, Jason Fegely, Philip Given, Joe Wamsley, Jeff Hixon, Jeff Hixon, Daniel Soveral, Melanie Wallace, Joe Wamsley, Shawn Huber

Newsworthy: Bil Bowden, Sara Zimmerman, Frank Bell, Jason Plotkin, Jason Plotkin, Jason Fegely, Jason Plotkin, Jason Plotkin, Jason Plotkin, Jason Plotkin, Gregg Peterson, Jeff Hixon, Jeff Hixon, Jason Plotkin, Jason Plotkin, Jason Plotkin, Kate Penn, Marcy Royce, Richard Hunsinger, Jeff Hixon, Jason Plotkin, Jason Plotkin, Kate Penn, Kate Penn, Kristin Murphy, Mary Williams, Ken Cooper, Kate Penn

Animals: Jeff Hixon, Heidi Pero, Diana Cramer, Daniel Soveral, Daniel Soveral, Jason Plotkin, Tracy Kaye, Bernard Siao, Christopher Glass, Marcy Royce, Jeffrey A. Moore, Jennifer Borror, Juliann Langeheine, Joanna Lopez, Susan Masenheimer, Marcy Royce, Kristin Murphy, Bil Bowden, Christopher Glass, Amy Staub, Juliann Langeheine, Juliann Langeheine, Janice Bender, Richard Hunsinger, Lauren Lloyd, Janice Zimmer, Lisa Catherman, Lisa Catherman, Amy Staub, Diana Cramer, Kristin Murphy, Abby Gibb, Janice Bender, Lori Jacobs, Shannon Sylte

Heritage: Amy Staub, Amy Staub, Amy Staub, Amy Staub, Amy Staub, Christopher Glass, Daphne Fuller, Amy Staub, Amy Staub, Christopher Glass, Paul Kuehnel, Dianne Bowders, Amy Staub, Amy Staub, Daphne Fuller, Christopher Glass, Dianne Bowders, Christi Bernlohr, Christopher Glass, Gaylord Lentz, Daphne Fuller, Christopher Glass, Christopher Glass, Christi Bernlohr, Kathleen Markey-Ludwick, Dianne Bowders, Christopher Glass, Steve Smith, Christopher Glass, Kathleen Markey-Ludwick, Dianne Bowders, Daphne Fuller, Christopher Glass, Jo Ott, Daphne Fuller, Teanna Byerts

Everyday Life: Audra Jon Hoover, Bil Bowden, Jason Plotkin, Jason Plotkin, Juliann Langeheine, Bil Bowden, Juliann Langeheine, Juliann Langeheine, Darin Potts, Christopher Glass, Jill Oles, Jeff Hixon, Jeff Hixon, Paul Kuehnel, Paul Kuehnel, Jason Plotkin, Jason Plotkin, Kristin Murphy, Kristin Murphy, Diana Cramer, Kristin Murphy, Terry Dietrich, Jennifer Borror, Steve Smith, Philip Woods, Paul Kuehnel, Jason Plotkin, Tracy Kaye, Tracy Kaye, Tracy Kaye, Diana Cramer, Tracy Kaye, Trinity Walker

Scapes Of All Sorts: Frank Bell, Joe Wamsley, Diana Cramer, Juliann Langeheine, Dwight Nadig, Tracy Kaye, Darin Potts, Janice Bender, Amy Staub, Tracy Kaye, Frank Bell, Diana Cramer, Megan Schroll, Megan Schroll, Janice Bender, Ken Borror, Darin Potts, Lisa Amspacher, Shawn Huber, Jeff Hixon, Joe Wamsley, Janice Bender, Rhonda Markel, Suzette Brumbaugh, Molly Fortenbaugh, Joe Wamsley, Patricia Teller, Dwight Nadig

Sports & Recreation: Jeff Hixon, Janice Bender, Patricia Teller, Philip Woods, Patrick Thomas, Ink Byers, Diana Cramer, Christopher Glass, Jeff Hixon, Diana Cramer, Amy Staub, Diana Cramer, Ink Byers, Jeff Hixon, Diana Cramer, Ink Byers, Kristin Murphy, Lyla Hess, Terry Dietrich, Diana Cramer, Diana Cramer, Ink Byers, Dwight Nadig, Jason Plotkin, Alan Horn, Mary Williams, Daniel Soveral, Diana Cramer, Bil Bowden, Wade Keller, Janice Zimmer, Jeffrey A. Moore, Ink Byers, Terry Dietrich

Local Flair: Amy Staub, Dianne Bowders, Amy Staub, Don Pressel, Amy Staub

Prize Winners

When picking from nearly 4,000 photos, it's difficult to nail down what separates the best photos from the rest — especially when so many photos are so good. To help, we enlisted thousands of local folks to vote for their favorite shots. The response was epic: almost 200,000 votes were cast. The voting helped shape what would eventually be published in this book. Please note, InYork.com photographers were not eligible for prizes. Along the way, the votes produced the prize winners below. Here's a brief explanation of how prizes were determined:

Peoples' Choice: This one's as simple as it sounds. The photo that gets the highest score, according to how folks voted, is given this award. We picked a different winner for the Editors' Choice award, but we think local folks are pretty smart too, so we wanted to reward the photo that people like the most. This is also one of the ways we figure out the grand prize.

Editors' Choice: This award goes to the photo our editors determine to be the best in a chapter. Sometimes it'll be a photo that fits the chapter so well that it stands out above the rest. Other times it could be a photo that is technically excellent. Our editors poured over submitted photos daily during the contest and were constantly thinking about which photo should be the "Editors' Choice." Our editors also helped pick the grand prize photo from a pool of Peoples' Choice photos.

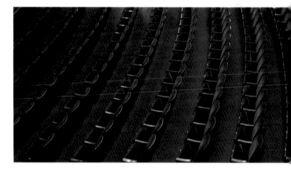

GRAND PRIZE WINNER
PHOTO BY FRANK BELL
page 19

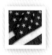

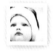
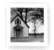
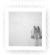
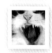
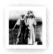

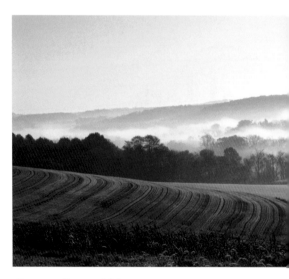

COVER SHOT WINNER
PHOTO BY MELANIE WALLACE
cover

Sponsors

Michael has been in real estate for over 20 years and is one of the lead agents on The Sold Team. He and his team have consistently been one of the top ten CENTURY 21® sales teams nationally from 2002-present. Michael's expertise is in land developing, new home construction, residential and commercial sales as well as investment properties. He also brings years of knowledge and experience in the finance and banking profession. He has strong ties to the community through civic and charitable organizations. In his free time, Michael enjoys golfing, traveling and spending time with family and friends. Please feel free to contact Michael for all your real estate needs.

The Art Institute of York – Pennsylvania traces its roots back to 1952, when it was founded by local artists as the York Academy of Arts. After more than six decades, The Art Institute of York continues to help students achieve their goal of a career in the creative and applied arts. They offer Bachelor's degrees in Fashion & Retail Management, Graphic Design, Interior Design, Media Arts & Animation, and Web Design & Interactive Media, as well as Associate's degrees in Graphic Design and Kitchen & Bath Design. Students receive hands-on learning from knowledgeable faculty with real-world experience, while using industry-related equipment and technologies.

The campus, located in Springettsbury Township, has over 20 classrooms and studios, computer labs as well as school-sponsored housing. It also features a Community Art Gallery, library and art supply & book store, all of which are open to the public. Learn more about York's leader in creative education at www.artinstitutes.edu/york.

InYork.com is the online hub for the York Daily Record, York Sunday News, The York Dispatch and Weekly Record. Log on for a sampling of the day's top stories—whether it be local, state, national, business, sports or entertainment news. Looking for something? Navigate to the site's Marketplace for auto, home, rental and job listings at your fingertips. Share the news with InYork.com as well. It's easy to announce your engagement, wedding or anniversary—choose from online or in paper publication, or both. Don't forget to sign up for a newspaper subscription of your own at InYork.com and discover even more of what the newspapers of York County have to offer.

Thank you!